Teach yourself
Painting
AND
Drawing

Teach yourself

Painting
AND
Drawing

Carole Vincent

Photographs by
JOHN BESWICK

BLANDFORD PRESS
POOLE DORSET

First published in the U.K. 1983 by Blandford Press, Link House, West Street, Poole, Dorset, BH15 1LL

Reprinted in this paperback edition 1985

Distributed in the United States by Sterling Publishing Co., Inc., 2 Park Avenue, New York, N.Y. 10016

British Library Cataloguing in Publication Data

Vincent, Carole
 Teach yourself painting and drawing.
 1. Painting—Technique
 I. Title
 751.4 ND1500

ISBN 0 7137 1228 7 (Hardback)
* 0 7137 1580 4 (Paperback)*

Typeset by Megaron Typesetting, Boscombe, Bournemouth.

Printed in Singapore by Toppan Printing Co(s) Ltd.

Contents

Acknowledgements

The author and publishers wish to thank the following students (in ages ranging from 10 to over 80) for permission to include their paintings and drawings in this volume. The plate numbers refer to work reproduced in colour, and the page numbers to work reproduced in black and white.

Matthew Bacon 47, 48. **Ben Barrell** 51 *below right*. **Christopher Barrell** Plate 8 *centre right*; Plate 15 *centre left, below and right*; 78, 90 *right*, 93 *top right*. **Katy Barrell** 50 *left*, 51 *centre left*. **Matthew Barrell** 51 *below left*. **Charles Bayfield** 45 *left*. **Margaret Brereton** Plate 9 *top left, below left*; 77 *top right*; 101. **Nora Bryan** Plate 5 *below left;* Plate 9 *below right*; 106 *top right*. **Millicent Bury** Plate 5 *centre left*; Plate 10 *top left*; 79 *top*; 106 *below right*; 107 *below*. **Benjamin Cork** 84 *top*; 90 *left*; 126 *top right*. **Ella Craig** Plate 1 *below left*; Plate 2 *below right*; 55 *centre*; 58 *top*; 77 *centre right*; 106 *top left*. **Fiona Crompton** 51 *top right*; 93 *below*; 102 *left*; 104, 105, 142 *right*. **Ann Davey** 49. **Michael Davey** Plate 14 *top left, top right, centre left, centre right, below left, below right*; 46, 51 *centre right*, 55 *right*. **Betty Denham** Plate 4 *top right, centre right, below right*; 64 *below*; 103 *left*; 149. **Mary Edward-Collins** Plate 3 *top right*; Plate 7 *below left*; Plate 9 *top right*; Plate 10 *below left*; 107 *top right*. **Anthony Fanshawe** 50 *right*, 169. **Susanna Fanshawe** Plate 8 *below left*; Plate 10, 169 *top right*. **Rosemary Freestone** Plate 3 *bottom right*; 83, 90 *margin*; 95 *right*; 154, 155. **Barbara Hamley** Plate 1 *top right*; Plate 2 *below left*; 55 *top*; 58 *below*; 66 *left*. **Teresa Hircock** 51 *top left*. **Molly Hogg** Plate 5 *top right*; Plate 7 *top left*. **Pam D'Ivernois** Plate 4 *below left*; Plate 8 *top left*; 77 *centre*; 80, 85, 151. **Helen Lawrence** Plate 6 *top left, top right, below*; Plate 11, Plate 12; 76, 91, 113, 156, 157. **Toni Mander** Plate 1 *centre right*; Plate 2 *top left*; 45, 55 *left*; 65, 79 *below left*. **Geraldine Mead** 123, 124, 126 *below*; 136, 138, 139, 140, 141. **Sharon Power** Plate 7 *top right*; Plate 13 *top left, top right, below left, below right*; 86, 92, 95 *top left*; 117, 118, 142 *left*, 169. **Joan Prout** Plate 8 *top right*; 95 *below left*; 106 *below left*. **Gillian Saville** 103 *right*. **Michael Severn** 107 *top left*. **Penny Severn** 77 *below right*, 102. **Maureen Staple** Plate 3 *top left*; Plate 5 *below right*; 77 *top left*; 79 *centre*; 93 *top left*. **Pat Stanton-Nadin** Plate 1 *top left*; Plate 5 *top left*; 57. **Sarah Talbot-Ponsonby** Plate 4 *top left*; 66 *below*; 82, 84 *below*. **Colin Wadey** Plate 7 *below right;* Plate 8 *centre left, below right*; 126 *top left*; 143. **Kaye Wadey** Plate 3 *centre left*; Plate 10 *below right*; 77 *below left*; 96. **Marjorie Westwell** Plate 1 *below right*; Plate 2 *top right*; 58 *left*; 66 *right*. **Arthur Williams** Plate 3 *below left*; 64 *top*; 77 *centre left*; 79 *below right*.

The author would also like to thank all her other students, past and present. She is grateful to A. Mary Shaw for corrections to the manuscript, Cleo Murch for typing it, Joss Cameron at Green & Stone Ltd, 259 King's Road, Chelsea, London S.W.3., for help with materials, and to Roy Gasson, Felicity Carter, and Crispin Goodall of her publishers.

Introduction

Introduction

I hope you will feel when using this book that it is like meeting a fellow artist who understands the problems, can give you practical advice, make suggestions, and provide the stimulus and incentive to develop your understanding of Art. I do not set out to give instant solutions. If you want to learn to paint and draw in a way that is as individual to you as your own handwriting, work from this book but do not expect too many short cuts.

Not everyone who wants to study painting and drawing wishes to go to classes; some find that the classes they attend do not provide the information they need, and others want guidance to pursue their studies beyond the scope of the class. At one time or another you may well have said —

'I'd like to work in oils, but what should I buy?'

'Painting is great in the summer when I can go out, but what can I do in the winter?'

'How can I find out more about colour?'

'I've been asked to put up a display of my work, how can I go about it?'

'Where can I find some fresh ideas?'

If you have asked these questions, and others like them, you need look no further for help.

It is not intended that everyone should work systematically through the book, although many will find that it does provide a logical progression from deciding what to buy and how to get started to many ideas for development, a chapter on understanding the language of Art, and finally to suggestions for the presentation of work.

It is up to you how you work through the book and how long it takes, but I hope that you will thereby increase your awareness and enjoyment of what you see, and acquire the means of expression to do it.

Chapter 1
Materials,
Equipment and
Preparation

If you are a beginner, the wide variety of art materials on display in a shop may look quite formidable. Well-meaning friends confuse choices even further by recommendations of materials they have found useful but which may not be appropriate for you. A beginner needs to choose wisely to allow freedom to experiment, without too many technical problems or great expense.

The lists in this chapter give a guide as to what is available and advice on the minimum you should buy to experiment in one particular medium. The lists will also help those with some experience in one medium who wish to experiment or transfer to another. The selection is a personal choice and other artists may recommend alternatives, but listing too many options would be confusing.

Good working practices are important. Artists are often licensed to be undisciplined and impractical but, in fact, this is not true of most professionals. Renoir said 'Be a good craftsman, it won't stop you being a genius', or as Michael, aged eleven, was heard to say, 'I'm not a perfectionist, I'm just doing it properly.' You should learn to do it properly from the beginning, as bad working habits, once acquired, are difficult to break.

Materials for Drawing

PENCILS are available in a range of 6H, 5H, 4H, 3H, 2H, H, HB, B, 2B, 3B, 4B, 5B, 6B, with 6H being the hardest and 6B the softest. Generally, the harder pencils are more suitable for technical drawing and those in the B to 6B range more suitable for artists.

CHARCOAL is made from twigs, usually willow, partially burned. It is sold in assorted sizes or thin, medium, and thick, or as charcoal pencils. It is a good medium for drawing, particularly on a large scale. It can be combined with chalks. Charcoal smudges easily and needs the use of a fixative.

CHALKS of the school variety are cheap and easy to use on a large scale, although the range of colours is limited.

CONTÉ sticks give a similar effect to charcoal and chalk but are harder, and of better quality than chalks. They are generally available in black, red, brown, and white. They do not smudge as easily as charcoal and are a good medium for quick sketching.

PASTELS are coloured pigments bound with gum (or oil). The crudest form are school chalks. Artist's soft pastels are the best, very expensive, with an enormous range of colours. They are available in boxes of assorted colours, or pastels for landscape or portrait, or are available singly. The choice is so large that a small set may be the best way to start a collection. Pastels are easily smudged and should be treated with great care, or fixed with a special fixative. Oil pastels cannot be rubbed or smudged like ordinary pastels and this may give the work a harder quality, but by using a rag dipped in turpentine lighter washes and blending can be produced to soften the effect.

CRAYONS AND CRAYON PENCILS are pigments bound with wax. Wax crayons are usually associated with children's work and the colour range is limited. Crayon pencils have a wider range of colours and some are water soluble which allows for washes of colour. They are good for delicate work with pencil where colour is needed.

PENS There is a wide choice and which you choose will depend on the type of work you do. A felt pen, fibre-tip pen, biro or smooth-nibbed fountain pen will give a dense black line and using them to experiment will help you to decide which of the more permanent and acceptable pens to buy. Traditionally, pen drawing was done with quills or bamboo sticks, cut and shaped to the size required. Their more modern equivalents are mapping pens or drawing pens. These pens give a sensitive and flexible line but their use requires much dipping into the ink. More convenient to use is the technical drawing pen. It is filled with permanent ink and, provided it is well cared for, gives very satisfactory results in drawing. There is a range of nib sizes from 0.1 to 2.0 — an 0.3 and 0.6 would suit most needs, but they are very expensive.

BRUSHES FOR DRAWING can be the same as you use for painting. What type and size you need will depend upon the medium used and the scale of work. A No. 1 and a No. 3 sable brush would do for inks and watercolours but you may need a larger brush as well. If you intend to draw with thinned oil paint, poster paint or acrylic, you will need a bristle brush.

INKS Drawing inks are waterproof when dry but can be reduced to a wash with water. The colours are bright and transparent and effects similar to printing can be obtained by overlaying colours. There is a wide colour range available but, to experiement, the following would be suitable: black or sepia for monochrome, plus cobalt, vermilion and yellow.

PAINTS Any paints are suitable for drawing.

PAPER There is a wide choice of papers available and almost any sort will do.

- *Cartridge paper* is suitable for most types of drawing.
- *Newsprint* is cheap and useful for rough sketching.

- *Sugar paper, cover paper, ingres paper* are all suitable for chalks, charcoal and pastels, and opaque paints.

- *Card* — a smooth-surfaced and non-absorbent card, such as Ivorex board or Bristol board, is suitable for pen work. Most printers have cheaper alternatives.

EQUIPMENT
- Drawing board 610mm × 457mm (24in × 18in).
- Drawing board clips, or sticky tape, drawing pins, or even clothes pegs.
- Rubber.
- Knife or pencil sharpener.
- Fixative spray for pastels, chalk, conté or charcoal drawings.

What to buy

PENCILS — B, 2B, 4B.
Student's cartridge paper — A3 or Quarter Imperial size in sheets or pad.
Putty rubber.

CHARCOAL — assorted sizes.
Chalk — white, school variety.
Sugar paper or brown wrapping paper or student's cartridge paper.

CONTÉ — one stick each of black, white and red.
Sugar paper or brown wrapping paper or student's cartridge paper.

PASTELS — beginner's selection of soft pastels or small set of oil pastels.
Sugar paper or brown wrapping paper or student's cartridge paper.
Possibly a fixative for soft pastels, although some people do not agree with using it.

CRAYONS or crayon pencils — small set.
Student's cartridge paper.

PENS—fibre tip fine and medium, or biro, or fountain pen.
Student's cartridge paper.
A technical drawing pen with 0.3 and 0.6 nibs.
Card.

PEN OR BRUSH, AND INK — drawing pen with a selection of steel nibs.
Sable brushes No. 1 and No. 3 and maybe No. 7 for washes.
Ink — black Indian or sepia, plus cobalt, vermilion and yellow waterproof inks.
Card or student's cartridge paper.

Paints

Paints are powdered pigments mixed with a binder.
- *Water-colour:* pigment bound with gum.
- *Oil:* pigment bound with linseed oil.
- *Acrylic:* pigment bound with a polymer emulsion.
- *Egg tempera:* pigment bound with egg yolk and oil.

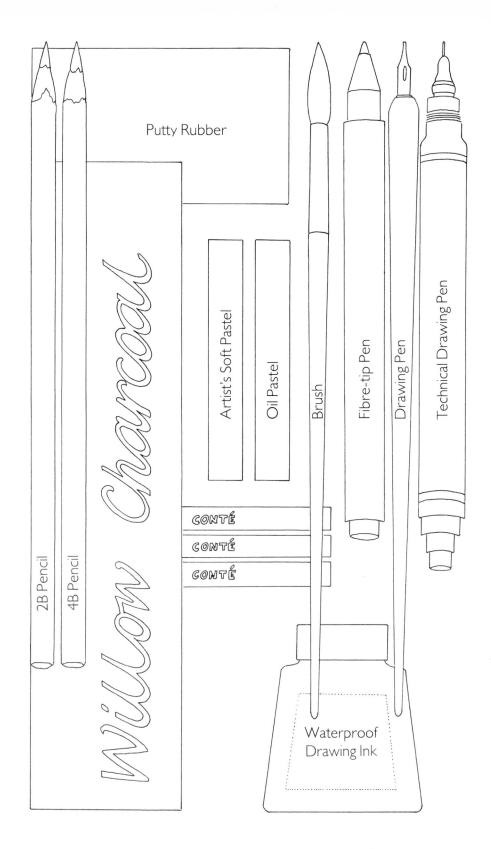

2B Pencil

4B Pencil

Willow Charcoal

Putty Rubber

Artist's Soft Pastel

Oil Pastel

CONTÉ

CONTÉ

CONTÉ

Brush

Fibre-tip Pen

Drawing Pen

Technical Drawing Pen

Waterproof
Drawing Ink

POSTER PAINTS There is more body in poster colours than in gouache which makes them suitable for larger work. They are relatively cheap, flexible in use and an ideal medium for beginners, classwork, studies for oil paintings, and large-scale work, such as scenery, when quick and effective results are important.

POWDER COLOURS These have the same advantages as poster colours but they are cheaper and can be used with the wet brush method, or mixed with water to the thickness required. PVA medium can be added to produce an acrylic paint. Powder colours are good for large-scale work and are a suitable medium for beginners of all ages.

WATER-COLOUR is often used to describe several types of paint, ranging from transparent water-colours in the accepted meaning of the word, to gouache, poster and powder colours which are opaque water-colours.

ARTIST'S WATER-COLOURS Transparent washes and layers of colour are applied to the paper, working from light to dark. Highlights and white are the white of the paper. This is not a medium suitable for beginners.

DESIGNER'S GOUACHE PAINTS These are the finest of the opaque water-colours and suitable for the inexperienced who want to work with water-colour. It is possible to use the paint in thin layers and build up thicker layers of paint with techniques similar to those used in oil painting. On the whole, gouache is more suitable for small-scale work.

OIL PAINTS The smell and feel of oil paints is attractive. They are flexible and easy to handle and the colours do not fade when dry. Mistakes can be rubbed or scraped away or covered over. Outdoors, they do not dry too quickly. But a beginner's oil painting is more obviously a beginner's than in any other medium. The techniques of handling the paint successfully take a long time to learn and the basic groundwork is probably better learned with poster paint.

ACRYLIC PAINTS These have many advantages: they are mixed and cleaned with water, the colours do not fade, they are fixed when dry. However, they do dry very quickly and seem extravagant in use compared with oil paints. On boards, the results can appear somewhat plastic. They are almost too instant for beginners but would suit those who like poster colours and want something more permanent and better quality colour.

EGG TEMPERA This is one of the oldest techniques in painting. For those who like the fine results of gouache painting it would be worthwhile to try it out — the results will be more luminous and permanent. Some poster or gouache colours are described as tempera but are not the same as egg tempera. These paints can be bought in tubes. This is definitely not a medium for beginners.

Many paints in the artist's range are often based on expensive metallic pigments. Cheaper paints are made with organic pigments which are similar but do not have the same durability. The cheapest paints, such as powder colours,

use fillers like china clay to extend the paint. The beginner will find the cheaper paints quite acceptable.

For general use and to find out the techniques and methods of working most natural to you, poster colour and powder colour have all the advantages. By using these relatively cheap paints, which later on provide a quick and easy method to experiment and plan paintings, you will discover which of the more traditional types of paint you want to work with. If you enjoy all the qualities of poster paint and like working on reasonably large pieces of paper, you might change to acrylic paints. If you particularly like the textural qualities, want to work on a large scale, enjoy the colour, require greater flexibility and have the space available, then you may prefer oil paints. However, if you prefer working on a smaller scale, appreciate the subtle changes from a wash to opaque paint and consider you might eventually prefer water-colours, then you would be advised to buy gouache paints.

Most manufacturers produce sets of paints for beginners, which may make a good present but so often include colours you do not need. The beginner is advised to buy the minimum recommended, in quantities that will allow the freedom to experiment.

Poster and powder colours, gouache and water-colours, oil paints and acrylic paints are discussed in detail.

Poster Paints and Powder Colour

PAINTS Some of the sizes available: 28ml (1fl oz) pots or No. 8 tubes for poster paints, or No. 1 tin or 100g pack for powder colours, would be a reasonable buy to experiement in this medium.

Essential colours, adequate for experimenting:
 Brilliant Red (Poster or Ostwald Red, Vermilion)
 Brilliant Blue (Cobalt, Poster or Ostwald Blue)
 Lemon Yellow
 White

Useful colours which give a better range for mixing:
 Crimson
 Prussian Blue
 Brilliant Yellow
 Black
 Burnt Sienna
 Yellow Ochre
 Viridian

BRUSHES Bristle brushes are most suitable for poster and powder colours and a No. 6 and No. 10 flat bristle brush would do for a start. A sable-type round brush No. 5 would help with finer work.

PAPER Cartridge paper, sugar paper, cover paper or brown wrapping paper would be suitable for poster and powder colour painting. Buy several sheets of A2 or Half Imperial size which can be cut if needed.

Containers for poster and
powder paints.

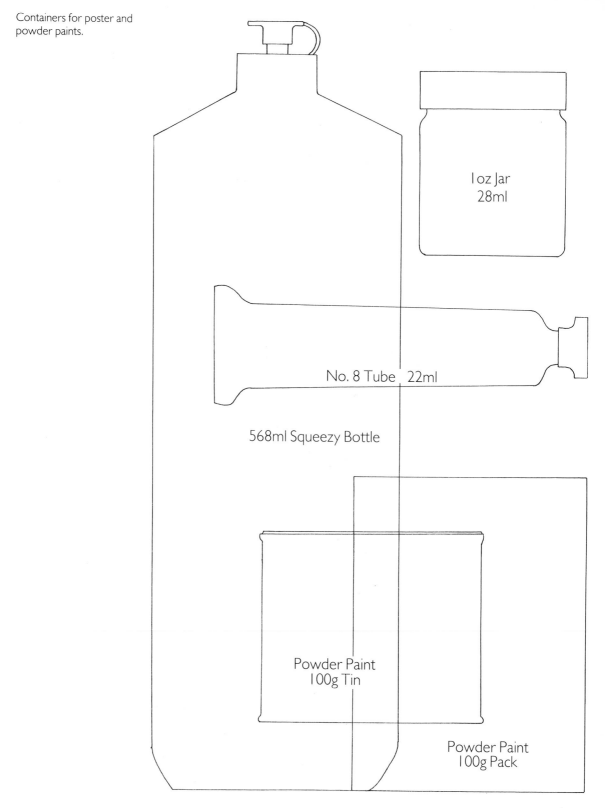

1 oz Jar
28ml

No. 8 Tube 22ml

568ml Squeezy Bottle

Powder Paint
100g Tin

Powder Paint
100g Pack

SUMMARY Minimum materials and equipment needed:

Paints Poster: 28ml (1fl oz) or No. 8 tubes, or
 Powder: No. 1 tin or 100g pack — Brilliant Red, Brilliant
 Blue, Lemon Yellow, White.
Brushes Two flat bristle brushes Nos 6 and 10.
 One round sable type brush No. 5.
Paper A2 or Half Imperial sheets of cartridge or sugar paper.
Board 610mm × 457mm (24in × 18in).
Mixing plates
Water pots

Gouache and Water-colour

PAINTS Designer's gouache is available in tubes No. 5 and No. 8.

Water-colours are available in tubes or pans in the artist's and economy ranges.

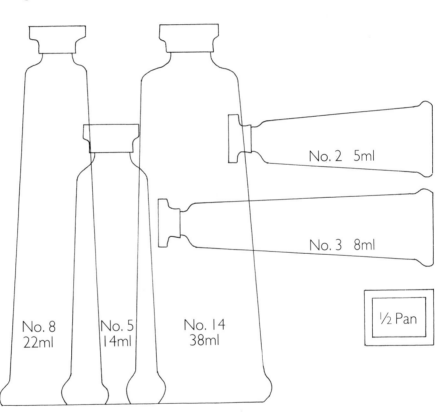

Tubes of gouache and water-colour.

No. 8 22ml No. 5 14ml No. 14 38ml No. 2 5ml No. 3 8ml ½ Pan

Water-colours are transparent colours, and gouache is an opaque water-colour. Beginners would be advised to start with gouache in No. 5 or No. 8 tubes and to introduce transparent water-colours at a later stage when they have more experience in handling the paints. However, you may have a water-colour paint-box, in which case supplement these colours with the basic gouache range. A little paint goes a long way. Some colours are much more

expensive in the designer's or artist's range — check the series number when buying — series A or 1 are the cheapest.

Essential colours, adequate for experimenting:
 Spectrum Red (Scarlet Lake, Flame Red)
 Cobalt Blue
 Lemon Yellow
 White

Useful colours which give a better range for mixing:
 Alizarin Crimson
 Prussian Blue, Ultramarine or Cerulean
 Spectrum Yellow
 Black
 Burnt Sienna or Light Red
 Yellow Ochre
 Raw Umber
 Viridian

BRUSHES Brushes of hair are the most suitable for water-colour and gouache painting and sable hair is the best. Try to afford sable for the smaller brushes (under No. 6) but a mixture of ox and sable will be adequate for larger brushes. As a start, try a No. 3 and No. 5 round brush and a No. 8 flat brush for washes. You can add to these later when you realise what you need.

PAPER Cartridge paper and water-colour papers are the most suitable. Experimental work can be done on student's cartridge, but paintings will be better on a slightly heavier paper which will need stretching. Several sheets of A3 or Quarter Imperial cartridge paper should be bought as a start.

SUMMARY Minimum materials and equipment needed:
Paints Gouache No. 5 or No. 8 tubes — Spectrum Red, Cobalt Blue,
 Lemon Yellow, White.
Brushes Two round sable brushes Nos 3 and 5.
 One flat ox and sable brush No. 8.
Paper Quarter Imperial or A3 cartridge paper.
Board 475mm × 305mm (18in × 12in).
Mixing Plates
Water Pots

Oils

PAINTS Artist's colours are pure pigments bound with oil. In the economy range organic or dye equivalents are often used and are marked 'hue'.
 Beginners should buy their basic colours in No. 14 tubes in the economy range. White seems to go more quickly so buy a No. 20 or No. 40 tube.

Essential colours, adequate for experimenting:
 Cadmium Red (hue)
 Cobalt Blue (hue)
 Lemon Yellow
 Titanium White

Useful colours which give a better range for mixing:
 Alizarin Crimson Light Red or Burnt Sienna
 Ultramarine Yellow Ochre
 Cadmium Yellow (hue) Raw Umber
 Cerulean Blue (hue)
 Black
 Viridian

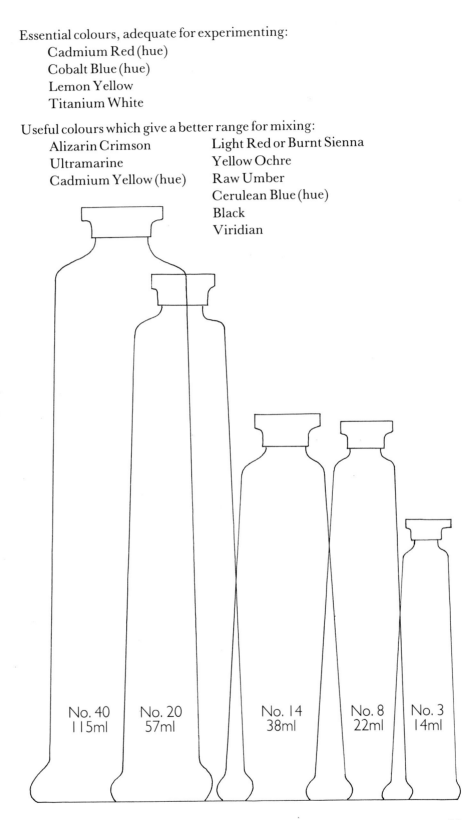

No. 40 No. 20 No. 14 No. 8 No. 3
115ml 57ml 38ml 22ml 14ml

Tubes of oil paints.

MEDIUM FOR MIXING, THINNING AND CLEANING Opinions vary as to what should or should not be used. The beginner will find that white spirit is the cheapest and adequate for all purposes. Painting mediums are available and can be useful to speed up drying. One third linseed oil and two thirds turpentine could be used if you feel that white spirit only makes the painting appear flat. Whichever you choose to use for mixing and thinning, white spirit will do for cleaning.

BRUSHES Bristle brushes, usually hog bristle, are the most suitable for oil painting. For finer work it is occasionally nice to use sable brushes and these could be bought later. A variety of shapes as well as sizes is available but a beginner would find two flat bristle brushes No. 6 and 10 adequate.

SUPPORTS (Canvases, boards, etc.) Basically you need a non-absorbent surface on which to paint. There are many surfaces which can be made suitable and they need not be expensive.

Canvas This is good to use but very expensive. It can be bought ready primed on stretchers. You may buy primed rolls of canvas more cheaply which you stretch yourself, or unprimed rolls for stretching and priming, which takes time, skill and hard work. The beginner would be advised to use other supports.

Hardboard This is cheap, permanent, easily obtainable and easily cut. Use the smooth side and rub with sandpaper before priming. Some people find it a bit slippery to work on. Butter muslin or thin cotton cloth can be glued onto the board which gives a suface similar to canvas.

Sundeala, Chipboard, Ceiling Board These are similar to hardboard to use but have the advantage of being thicker. Worth trying as different surfaces to work on but all need good priming.

Plywood Good surface but fairly expensive. It tends to splinter on sawn edges and needs good priming.

Prepared boards (Daler boards): Easily obtainable in many sizes in art shops. The surface is pseudo-canvas and slippery. They are convenient, but expensive for what you get.

Cardboard Needs to be well primed as the surface is absorbent. It is a cheap, good surface to work on but not very permanent.

Paper Can be bought prepared for oil painting but the surface is slippery and you can prepare your own much more cheaply. A reasonable quality cartridge paper, cover paper, or brown wrapping paper can be stretched and sized to make a very satisfactory and cheap painting surface.

PREPARING THE SURFACE It is essential to preserve the support and give a suitable ground on which to work in oil paints. Sizing makes the surface less

absorbent and priming makes a suitable ground. The process can be complicated if it is done with a professional artist's thoroughness, but the beginner need not be concerned except to make a reasonable non-absorbent surface.

Size Use weak animal glue size, or a thin coat of emulsion, or acrylic primer.

Priming For greater permanence and a more suitable surface, use one or two coats of an acrylic-based primer, or a good quality emulsion paint, or oil-based undercoat.

WHICH SUPPORT TO CHOOSE Paper is the cheapest and ideal for the beginner. Hardboard or cardboard are also reasonable. Other supports should be tried, but expense and preparation often inhibit the beginner who needs to feel free to experiment and work on a variety of sizes.

SUMMARY	Minimum materials and equipment needed.
Paints	No. 14 tubes — Cadmium Red (hue), Cobalt Blue (hue), Lemon Yellow.
	No. 20 tube — Titanium White.
Medium	Turpentine substitute or white spirit.
Brushes	Two flat bristle brushes Nos 6 and 10.
Support	A2 or Half Imperial cartridge paper, or cover paper, or brown wrapping paper.
	Glue size.
	Gummed brown paper tape.
	Board 610mm × 457mm (24in × 18in) or hardboard, or cardboard.
	Emulsion paint.

Palette
Two glass pots — for mixing and cleaning mediums.
Palette knife
Rags

Acrylic and PVA

Acrylic paints vary in quality depending on whether they are produced for the professional, college or school market. You can mix your own PVA paint by using PVA medium with powder, or added to poster, gouache and watercolour paints.

PAINTS Essential colours, adequate for experimenting:

Bright Red (Brilliant Red, Vermilion)	Lemon Yellow
Cobalt Blue	White

Useful colours, which give a better range for mixing:

Crimson	Cerulean Blue
Ultramarine	Yellow Ochre
Brilliant Yellow or Cadmium Yellow	Raw Umber
Burnt Sienna	Black

MIXING AND THINNING Acrylic and PVA colours can be mixed with and are reduced by water. The paint when dry is waterproof and resilient — remember this also applies to your brushes, so clean them with water immediately after use. A gel retarder is available which slows down the drying of the paint and is useful when working outdoors.

135ml

No. 14
38ml

2fl oz
59ml

Tubes of acrylic and PVA colours.

24

BRUSHES What you need to buy depends on the type and scale of work you will do. Most people starting with acrylic have used other paints before and, therefore, have a collection of brushes. Beginners should buy two flat bristle brushes Nos 6 and 10 and later extend the range and shapes, including a couple of sable brushes for fine work.

PAPER, BOARDS, ETC. Almost any surface can be made suitable for acrylic paints. Beginners should use a reasonable quality cartridge, sugar paper, cover paper, or brown wrapping paper. These papers do not need sizing, but stretching the paper gives better results for paintings. The information on supports given in the oil painting section applies also to acrylic paintings, and any of these surfaces may be tried.

SUMMARY Minimum materials and equipment needed:
Paints Tubes — Bright Red, Cobalt Blue, Lemon Yellow, White.
Brushes Two flat bristle brushes Nos 6 and 10.
Paper A2 or Half Imperial cartridge, sugar paper, cover paper,
 brown wrapping paper, hardboard or cardboard, etc.
Drawing Board 610mm × 457mm (24in × 18in).
Palette
Two Jars
Palette knife
Rags

Basic Equipment There are some pieces of equipment you will need whichever medium you decide to work in. It would be better to make do where you can at first, and only buy that which is essential.

DRAWING BOARD Those you can buy as drawing boards are often heavy and expensive. Basically, you need a flat surface, large enough for A2 or Half Imperial paper and which will not warp. 10mm (⅜in) chipboard is ideal and will last for years. 610mm × 457mm (24in × 18in) would suit most purposes, or half this size for small gouache and water-colour paintings.

DRAWING BOARD CLIPS Those sold as such are not much use on thin chipboard. Instead, you could use large clothes pegs or sticky tape.

PALETTE The traditional hook-shape or oblong wooden palette with thumb-hole is expensive and it is not easy to see the colours you are mixing. For oil painting, a double-sided, light-coloured formica board about 300mm × 200mm (12in × 8in) or larger, makes an ideal palette. Alternatively, you can buy 'tear-off' palette pads or make your own by using a clip-board with sheets of grease-proof paper. Thick glass or china slabs are also suitable. For poster paint, or gouache, a couple of old china or enamel plates will do. When mixing thin washes of paint, or using powder paint, containers such as old margarine tubs, bun tins, or ice-cube boxes are useful. Any of the above will do for acrylic paints but if you have problems keeping the paint moist, then 'stay-wet' palettes are available.

DIPPERS, or containers for water and white spirit: clip-on metal double or single dippers are available to the oil painter. These are useful if you like to hold the palette in your hand. Otherwise small glass jars will do. Larger jam jars will be needed for water-based paints.

RAGS Always keep plenty of cotton rags for wiping your brushes and cleaning up.

EASEL Some sort of support for your painting will be necessary. Easels are expensive and, at the beginning, it is unlikely you will know what you want — it could be a large studio easel, a metal or wood portable easel, or just a table easel. You can make do on a table with a block of wood to raise the board to an angle or, if a table is inconvenient, you can improvise with an old kitchen chair. Have the seat facing you and use two small nails, or a piece of wood tied across, and you can have the equivalent of an easel. If you prefer your work nearer to you, turn the chair around and support your board between your lap and the chair back. A small step-ladder could be used for the same purpose.

PAINT BOXES These can be very attractive but are often heavy and usually expensive. Basically, you need a container for your paints that is easy to carry around. At home, a tray is ideal. Plastic containers or cardboard boxes work very well and can be carried in a basket or haversack. Brushes can be kept in a tube or a sectioned cloth wrap similar to that used for carvers' chisels. If you make one of these, have the sections running from both sides so that the bristles are protected in the middle. White spirit or water can be kept in screw-top jars.

STICKY TAPE You will find two sorts useful. Brown gummed paper tape for stretching paper — nothing else will do — and masking tape for many other jobs.

CUTTING KNIFE This must be sharp for cutting paper — small, plastic-cased knives with snap-off blades are ideal and relatively cheap.

RULER, SET SQUARE Wooden or plastic rulers tend to get damaged when used as an edge for cutting paper. Steel rulers are ideal but expensive; you can, in fact, make do with a piece of metal carpet edging. The set square is to check for right-angles when trimming paintings or cutting paper.

RUBBERS Putty rubbers are the best but they are expensive. If you buy a plastic alternative, then check that it rubs away pencil and not paper.

HOUSEHOLD BRUSH This will be necessary for priming boards or canvases and can be used as an alternative to the larger artist's brushes when covering big areas. A good brush about 50mm or 2in wide would do.

Brushes

There is a basic choice of bristle, hair or nylon. What you buy will depend on the use for which it is intended. Normally, bristle brushes are for oil painting, acrylic, and poster work; hair brushes are for water-colours, gouache, and fine poster work. Nylon brushes are made as equivalents to both bristle and hair.

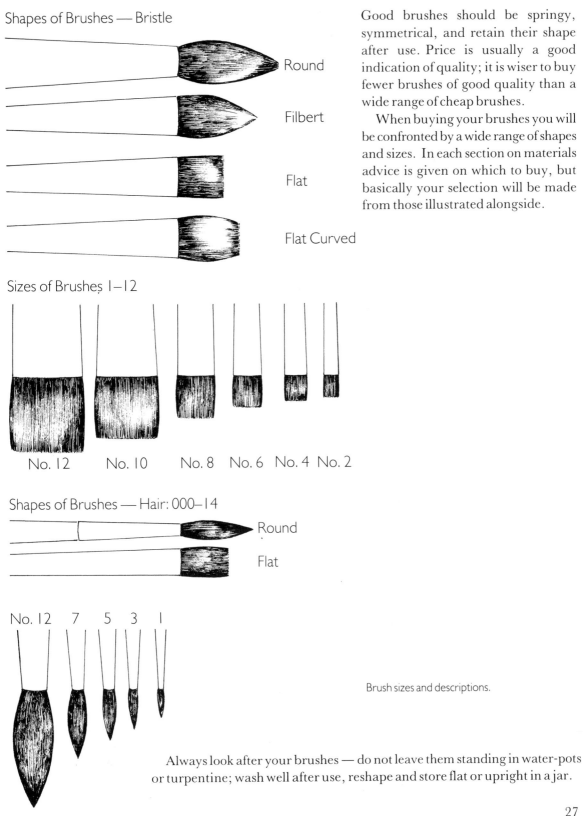

Shapes of Brushes — Bristle

Round

Filbert

Flat

Flat Curved

Sizes of Brushes 1–12

No. 12 No. 10 No. 8 No. 6 No. 4 No. 2

Shapes of Brushes — Hair: 000–14

Round

Flat

No. 12 7 5 3 1

Good brushes should be springy, symmetrical, and retain their shape after use. Price is usually a good indication of quality; it is wiser to buy fewer brushes of good quality than a wide range of cheap brushes.

When buying your brushes you will be confronted by a wide range of shapes and sizes. In each section on materials advice is given on which to buy, but basically your selection will be made from those illustrated alongside.

Brush sizes and descriptions.

Always look after your brushes — do not leave them standing in water-pots or turpentine; wash well after use, reshape and store flat or upright in a jar.

Painting and Palette Knives

For oil painting and acrylic painting you will need a knife to mix your paints and clean your palette. Palette knives are sturdier than painting knives and can also be used for applying paint, but the range of shapes available in painting knives may appeal to you.

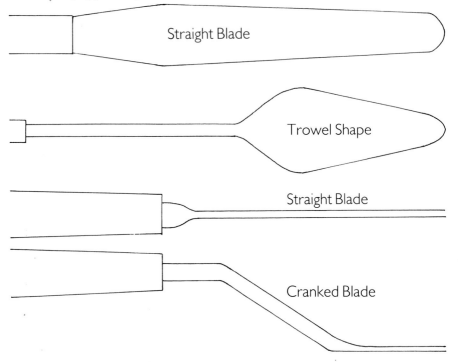

Straight Blade

Trowel Shape

Straight Blade

Cranked Blade

Paper

There is a wide choice of paper types and sizes in which to buy it. Good paper can be very expensive so that the cost inhibits use: you need to buy it only if you are concerned about your market in fifty years or so. Over a period of time you probably will require paper suitable for rough sketching, for drawings and for water-colours, gouache, poster paint, for oil sketches, or for acrylics. It is advisable to keep at least two qualities of paper so that good paper is not wasted by rough sketching. Each section on materials gives advice on the best paper to buy for each purpose. A few facts will help you to understand the selections:

NEWSPRINT OR KITCHEN PAPER A poor quality, thin and absorbent paper, nevertheless useful for rough sketching because it is so cheap. More likely to be obtainable from a paper and packaging firm which supplies fish and chip shops, among others.

CARTRIDGE DRAWING PAPER This is available in several weights, the cheapest and the lightest being student's quality (about 90gsm or 50lbs (twice the weight of newsprint) and the heaviest being engineer's paper (about 192gsm or 105lbs). The student's quality is suitable for drawing and colour sketches, but not strong enough to be stretched for water-colour painting. A cartridge paper of 120gsm or 65lbs would be suitable for most purposes in drawing and painting.

ARTIST'S WATER-COLOUR PAPER This paper when made of rags and not wood pulp can be very expensive but will last for generations. However, good water-colour paper is available at a reasonable price and that, of course, depends upon its weight. The lighter paper (about 145gsm or 72lbs) will need stretching for water-colour painting, but the heavier paper (about 290gsm or 140lbs) may not. The really heavy water-colour papers (about 610gsm or 300lbs) are almost like cardboard.

COLOURED PAPERS for pastels, charcoal or painting: these too, are available in a wide range and priced according to weight and quality. The cheapest to use is the non-shiny side of brown wrapping paper. Next, is sugar paper in a very limited colour range, but it is a good, strong paper. Pastel paper, cover paper (coloured cartridge paper) and poster paper are of reasonable quality and weight; they usually come in a wide range of colours. Stretched, they make a good surface for poster-colour work. There are several better quality and more expensive coloured papers.

TRACING PAPER Can be useful for experimental work and analysing drawings and paintings.

PAPER SIZES AND WEIGHTS can be very confusing. Most producers have adopted the International sizes but some are still manufactured and sold in traditional British sizes. The international sizes are given in metric form which for many people still needs translating into Imperial measurements. The following tables are intended to help you sort it out.

TRADITIONAL BRITISH DRAWING PAPER SIZES

	Millimetres	Inches (approx.)
Royal	610 × 483	24 × 19
Double Crown	762 × 508	30 × 20
Imperial	762 × 559	30 × 22
Double Elephant	1,016 × 686	40 × 27
Antiquarian	1,346 × 787	53 × 31

INTERNATIONAL PAPER SIZES

	Millimetres	Inches (approx.)
A0	841 × 1,189	33⅛ × 46¾
A1	594 × 841	23⅜ × 33⅛
A2	420 × 594	16½ × 23⅜
A3	297 × 420	11¾ × 16½
A4	210 × 297	8¼ × 11¾
A5	148 × 210	5⅞ × 8¼

The most common sizes and equivalents used by the artist:

A1	Imperial
A2	Half-Imperial
A3	Quarter Imperial
A4	

WEIGHTS OF PAPER International weights are based on the weight in grammes per square metre and Imperial weights are based on the weight in pounds per Imperial sized ream. As a rough guide:

	Metric	Imperial
Newsprint	45gsm	25lbs
Student's Cartridge Paper	90gsm	50lbs
Sugar Paper	110gsm	60lbs
Good Quality Cartridge Paper	145gsm	72lbs
Good Water-colour Paper	290gsm	140lbs

Paper can be bought in single sheets, by the quire (now accepted as 25 sheets), half-ream (250 sheets) and ream (500 sheets). Buying in pads or sketch books for paintings is convenient, but more expensive. On the whole it is cheaper to buy the larger sizes and cut to size when necessary. However, a sketch book or lay-out pad is desirable. The size depends on how you will use it. A small sketch book (A5 or 8 ½ in × 5 ½ in) with student's cartridge paper, spirally bound, is a useful size to take around for quick sketching. A larger lay-out pad (A4 or 9in × 12in) is useful to have at home for jotting down and working out ideas for paintings.

Stretching Paper

It is not essential to stretch paper but this does fix the paper to the board. Stretching stops the paper buckling when using water-based paints, and it is necessary if the paper is to be sized for oil painting. Good quality heavy water-colour paper may not need stretching, and it is a waste of time for sketches and studies.

MATERIALS NEEDED:
Drawing Board
Paper
Roll of brown gummed paper about 1in (25mm) wide. Sellotape or masking tape will not do.
Sponge

50mm (2in) brush
If the paper is being prepared for oil painting: glue size is mixed according to packet instructions. It can be kept in a screw-top jar for future use. Only use animal or vegetable-based size.

METHOD:
Cut the paper to the size required.

Cut the gummed paper strips slightly longer than the size of the paper.

Soak the sponge and wipe both sides of the paper as quickly as possible. The paper may buckle but do not worry.

Sponge each gummed strip in turn and fix paper to the board.

Leave to dry naturally — not in bright sunshine, or in front of a heater.

N.B. Sizing can be done after the paper has dried, or instead of sponging the upper side.

Fix the wetted paper onto the drawing board with gummed paper strips.

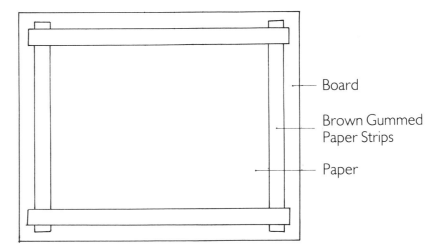

Board

Brown Gummed Paper Strips

Paper

Organising Your Working Area

Limited space, expensive carpets, or other people to consider can all be inhibiting factors when choosing to work in your own home. For those who are lucky enough to have a separate studio or working space the problem does not arise until the choice of subject matter makes you move your equipment and materials elsewhere — then, you too, need to be well organised.

DRAWING is quite easy to cope with — a chair to sit on and maybe another chair or table to support your drawing board is all you need.

PAINTING presents more problems but with a little thought and preparation they can be overcome. Decide how you will support your painting board — on a table, an easel, an old chair, step-ladder or shelf. To protect the floor keep an old mat, sheet or blanket for that purpose. Now consider where you will put your paints, brushes, pots, palette and rags which do need a lot of space and can make a mess. A small stool or another chair will do, in which case it would be easier for you to keep your materials on a tray. However, a trolley kept for the purpose provides an ideal storage unit underneath, with a paint table on top — it can be wheeled around and provide a permanent store for your painting equipment.

If you want to sit to work, have a chair or stool which is high enough to allow freedom of arm movements. A sitting position that is too low will make you poke at your work.

DAYLIGHT is the best working light. A mixture of a fluorescent daylight tube (placed near the source of daylight) and a yellow light is the best artificial alternative. Most people have little choice as to where they will work but do try to avoid changes of light during one painting. Remember it does help if you can see properly what you are doing!

Storing Your Materials

Paper should be kept flat and away from damp.

Paints and drawing materials can be stored in cardboard boxes, in a drawer, on a shelf, or on a tray or trolley.

Brushes should be stored flat or upright in a jar.

Turpentine or white spirit is inflammable, so store it in a safe place.

Boards and canvases should be stored vertically.

Paintings that have been done on paper and drawings should be stored flat, or in a folder.

Preparation for Working

Poster Colour

Poster colours are made with considerably more bulk than artist's colours, therefore you use more than you would with gouache. Spread your colours as far apart as possible on your palette.

Do not take too much paint — you can always add more, and remember that a little red goes a long way. About a level coffee spoon of paint would do as a start.

Have two areas of white — one for mixing and one for use on its own.

The colours can be used as thickly as they come, or be reduced with water to a wash. They dry much lighter than they appear when applied but you soon get used to this. If applied in too many thick layers, the colour will flake off. The finished painting can be fixed with a poster varnish to make it water-proof but this tends to darken the painting.

CLEANING Clean, unused paint can be returned to the jar. Dry paint can be remixed with water. Palette and brushes are cleaned under water.

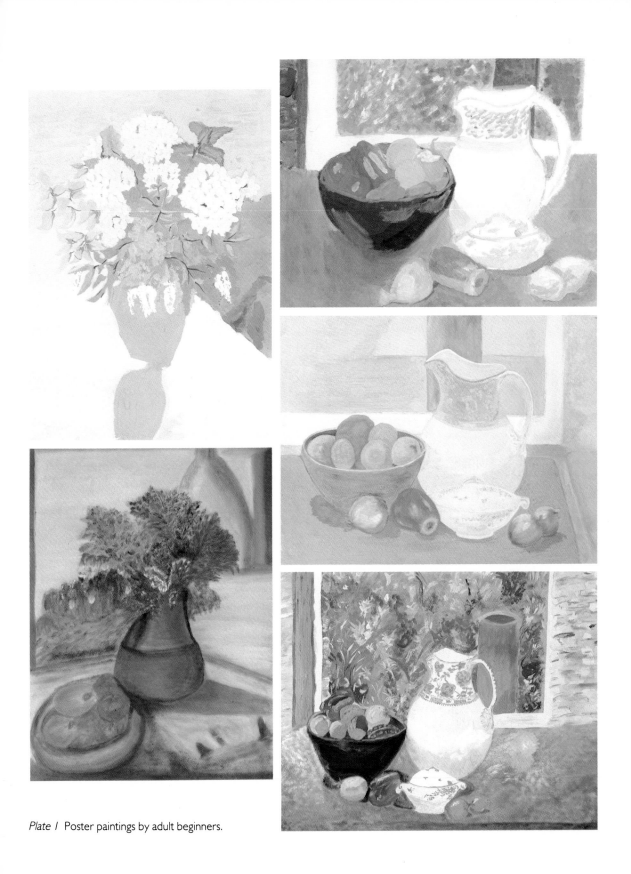

Plate 1 Poster paintings by adult beginners.

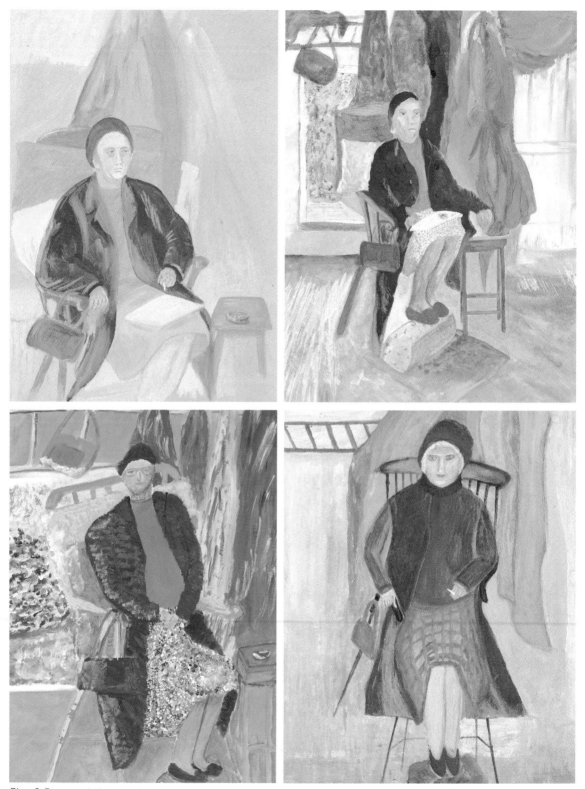

Plate 2 Poster paintings by adult beginners.

POWDER COLOURS These can be mixed with water to produce a paint similar to poster colours, or they can be used with a wet brush dipped into the dry powder and applied directly to the paper. Bun tins or small jars are useful for keeping the dry powder while you are working.

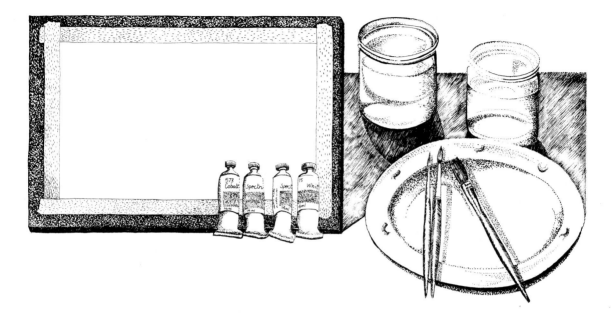

Gouache

Gouache paints are similar to poster colours to use but because they have not the same bulk a little paint goes a long way.

Spread your colours as far apart as possible on your palette to leave room for mixing.

Use very little paint, about 6mm, or ¼ in, is enough for a start.

Have two areas of white — one for mixing and one to use on its own.

The colours can be applied as water-colours in a wash being built up in thin layers, or applied more thickly. The covering power of gouache is good. The colours dry lighter than when they are put on.

CLEANING Dry paint can be remixed with water. Palette and brushes are cleaned under water.

WATER-COLOURS A pure water-colour technique of applying paint in washes of colour in transparent layers, without the use of white, is not advisable for a beginner. It is not within the scope of this book to teach the technique of water-colour painting. If water-colour paints have been purchased, then white should be added to the palette, and the student should work in a similar way to that in gouache painting.

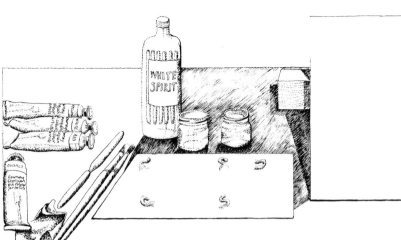

Oils Spread the colours as far apart as possible on your palette and leave the centre for mixing.

Do not take too much paint — you can always add more later. About 12mm (½ in) will do.

Have two areas of white, one for mixing and one to use on its own.

Use a knife for mixing large quantities of colour – your brushes need to be looked after. Try not to let the paint get into the roots of the hairs of the brush as it is then difficult to clean and the shape soon becomes distorted and then the brush is ruined.

MIXING AND THINING Use two containers with a little white spirit in each – one for mixing with the paints when required, and one for cleaning your brushes. Oil paints can be used straight from the tube, or thinned with white spirit to a transparent wash. Experience will tell you how much or how little you need to use. Thicker paint should overlay thinner paint, as a rule, or cracking may occur. It is often necessary in oil painting to leave work to dry out for a few days or the painting will become muddy.

CLEANING Oil and water do not mix! Clean your brushes with white spirit and wipe with a rag. At the end of a painting session, clean your brushes further, using soap and warm water, wash thoroughly, wipe dry and reshape. Store your brushes flat or upright in a jar. The palette should be scraped clean with a knife and then wiped with white spirit on a rag. Do not pour dirty white spirit down the sink!

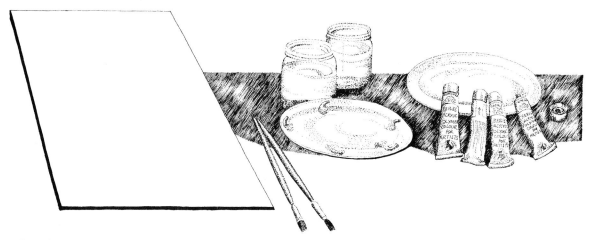

Acrylic

Acrylic paints dry very quickly which is an advantage when working one colour on top of another but a disadvantage on the palette. Dried out colours cannot be remixed. Acrylic paints can be used in a similar way to oil paints or poster paint, i.e. in thin washes, or straight from the tube with a brush or knife.

Spread the colours as far apart as possible on the palette. About 12mm (½ in) of paint from the tube should do — you can always add more.

Have two whites — one for mixing and one for use on its own.

MIXING AND CLEANING Acrylic paints, like emulsion paints, are reduced by water but are waterproof when dry. Keeping the colours wet enough for working is a problem, especially outdoors. You could use a retarder to slow down the drying or a 'stay-wet' palette, or use a water spray to moisten the paint from time to time.

If you decide to make your own acrylic paint using pigments and PVA medium you should obtain expert advice. However, if you are adding another medium to another paint such as poster, powder or gouache paint then about half the quantity of medium to paint should be mixed and reduced if necessary with water. The more PVA medium the more shiny the results will be.

Brushes and palette are cleaned under water. Brushes with hardened paint will need the appropriate solvent; palettes can be scraped clean with a razor.

Chapter 2
Getting Started

Getting started in drawing or painting is difficult. No doubt you will have to steel yourself to make your first marks on paper, but once you have seen and felt the qualities of paint, or have drawn an object that resembles the way it appears to you, the excitement should dispel your early anxieties. Obviously you will learn a lot from experience but the immediate problem is what you should do first. Should you start with drawing or painting? Usually there is no logical reason for starting with one rather than the other. — If you have pencils and paper you will experiment to see what you can do, and if you have paints you will probably not be able to wait to try them out. You may have done so already.

It would seem logical to start with drawing but you would need to be very strong minded to leave your paints until you had worked through the drawing section, so perhaps you should start with painting. Painting includes drawing and it has the added attraction of texture and colour. Really, the choice is individual. Nobody can be an absolute beginner even though it may be a long time since they made a conscious effort.

In both drawing and painting you need to know something about the medium you are working in before you make pictures. If you rely on instinct and childhood memories alone your work will be very limited. The exercises and experiments suggested are a sort of 'warming up' process. You will be able to explore ways of using the paint or pencil to give you confidence to attempt your first painting or drawing.

Once you have started you will progress very quickly until you reach a stage when you seem to be at a standstill. At this stage you will need some further incentive and knowledge to keep you working and getting better. The time when you need this varies from person to person, so that your progress through this book may take months or years. The order in which you use the suggestions of working will also be individual. You will learn to assess what is wrong with your work and find the information and studies necessary to help solve the problems.

Drawing

Drawing is about learning to see and expressing what you see in graphic terms. It is not just a means of identifying objects for a visual dictionary. Obviously, at first, if you can make an object resemble its appearance you will be pleased, but that is not the only goal. You will learn through drawing to explore the visual world — you will begin to see and understand subtleties of

lines and shapes and patterns that are not apparent to the casual observer. As you develop your abilities and power to see you will find an exciting new world.

Accuracy can be learned by practice. The way you record, explain, express in drawing what you see, will be as individual as your handwriting. So, where do you begin?

- You need to understand your materials.
- You need to find different ways of using them.
- You need to choose something to draw.
- And once you have started you need to know how to continue and develop your drawing.

The exercises or experiments at the beginning are to help you explore the range of marks and lines, depth and lightness of shading, patterns and textures that can be made with the drawing materials you have chosen. They seem to be elementary, but it is surprising how restricted your instinctive use of drawing tools can be. They can be used, also, by those with experience, to explore the possibilities of a new drawing medium.

Exercises to Understand Your Materials

Set up your working area in a good light and be comfortable.

Have your board slightly raised and make sure you can move your arm freely.

The following experiments refer to working in pencil but make a basis for getting to know any new drawing medium:

Write your name three times: at first very quickly, then deliberately and, thirdly, in capitals. Study the results: the first will be light and flowing, the second will be flowing but with changes of pressure, and the third will have short, firm strokes. These are variations in using a pencil that you are used to unconsciously. For the purpose of drawing you need a larger range.

Take a line across the page. Let it wander by curves, and then zig-zags; go quickly; go slowly; press harder; press very lightly.

39

Try short quick lines in various directions; then in the same direction; vary the pressure and make the lines heavier and lighter. Try dotted lines; then lines made from dashes.

Use your pencil on its side in various directions; then all in the same direction. Use it on its point when sharp, and when blunt.

Scribble in an area — press hard, and then lightly. Fill in an area with lines going in the same direction. Shade an area from light to dark with the pencil lines showing, and then not showing. Try other ways of covering an area — with dots, and dashes, then going from light to dark by using dots or dashes. Rub some of these areas with your finger, then lightly with a rubber. Use a rubber to make white lines across by rubbing away.

Draw a simple shape — a square or a circle will do — and see how differently it appears depending on how you do it. For example: a strong line around the shape; a light, sensitive line; a dotted line; a line that changes its weight. Fill in the shape in different ways, scribbling in different directions; going from dark to light; by dotting. Try the same ways to make a circle or square without the line around the outside and filling in the shading.

How to Start

Choose something to draw from what you see around you: two or three objects which belong together, such as a couple of mugs and a jug on the table; a jar with pencils and brushes in it, with a penknife, ruler, etc. beside it; a couple of potatoes and an onion on a chopping board; a pile of books on a shelf; a stack of flower pots and a trowel; a household plant on a window-sill.

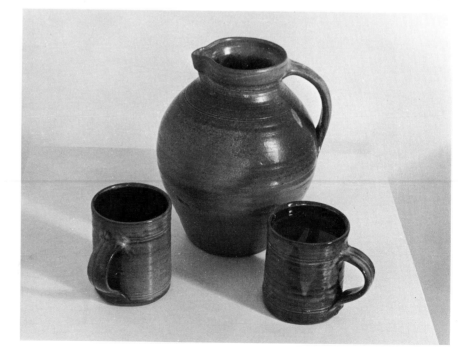

Sit yourself in a position where you can see your paper and what you are drawing by only raising your eyes. Never place yourself so that you have to move your head.

It is tempting to draw object by object and hope it will all fit together in the end. Try to avoid this.

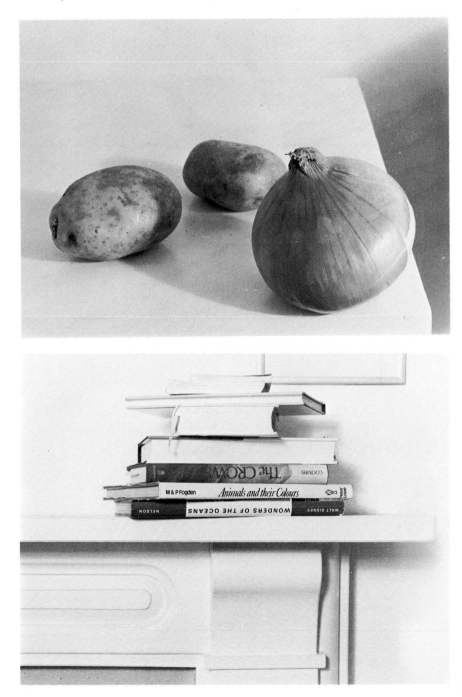

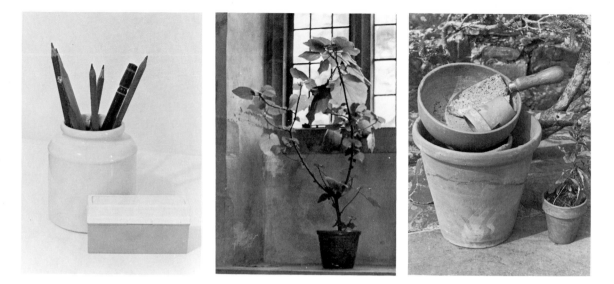

Start by using the pencil (2B) very lightly, hardly taking it off the paper, and sketch in very roughly the group or objects. In this way you will know whether you can get the group satisfactorily on your paper and, what is more important, you will have established the relationship of the objects to each other. At this stage, the relationship is more important than accuracy. Now, let the drawing grow from a point — an area where several shapes meet. For instance, draw the line of one side of the mug and establish where the base is. Then, see what links that line to the jug beside it; perhaps a shadow will take you across. Put this in and then the side of the jug, referring to the mug to get its relative height. Keep referring back to this starting area, and keep relating one object to another. This will help you to become more accurate and it will give your drawing some unity.

Different Ways of Drawing

You will learn quite a lot from your first drawing, about the way you see things and what you would like to be able to say about what you see. Consider the following questions:

- Are you very concerned about accuracy?
- Is light and shade important?
- Do you particularly like the linear quality of pencil?
- Do you like a lot of detail, patterns and textures?

A single drawing cannot express all these things. Try several drawings of the same group of objects from different angles, or other similar groups in a variety of ways.

ACCURACY Use line mainly, and shading where necessary. Start as before but this time try to be much more aware of the need to relate and measure one object against another, which means working across as small a distance as possible. When relating one mug to the next, look for and record any lines

from the background linking the two. Remember that you can expect to record small distances fairly accurately but complete shapes in outline are difficult to do. The proportions of objects, or the relations of objects to one another, also cause difficulties but there is a fairly simple way of checking.

Hold your pencil vertically and at arm's length. A fully stretched arm is important to maintain consistency in measuring.

Let the top of the pencil be level with the top of the mug, for instance, mark with your thumb the position of the bottom of the mug.

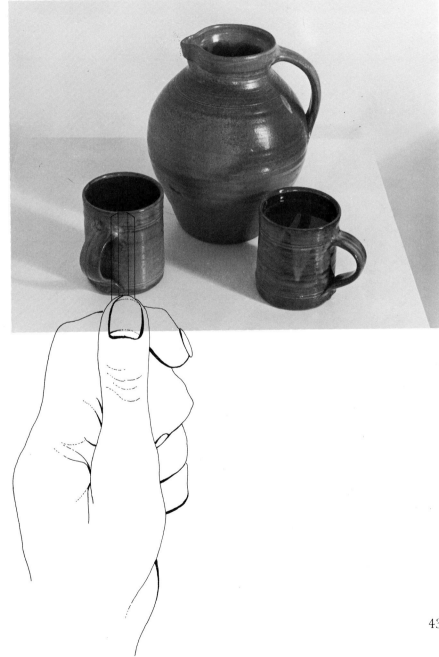

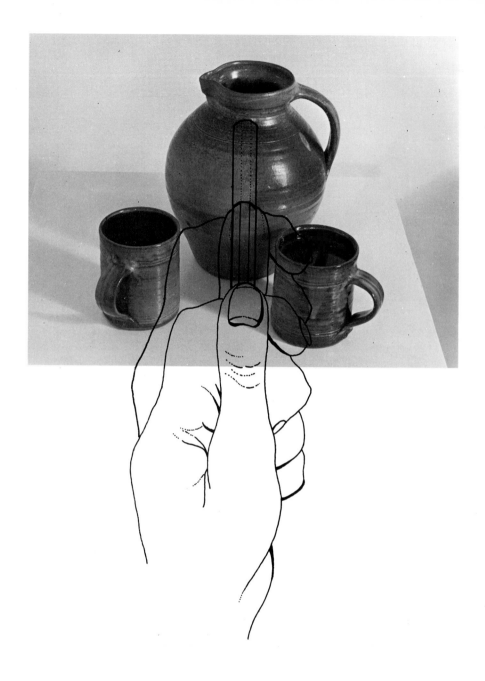

Now line up the pencil, keeping your thumb in that position, against the jug. How many times the height of the mug is the jug?

Check your drawing. Is the jug taller than the mug in the same proportion that you measured with your pencil? You can compare width with height in the same way. A combination of the two methods described, recording small distances only and checking proportions with your pencil should help to make more accurate drawings.

LIGHT AND SHADE Remember the exercises you did with shading. Start as before but, where possible, use lighter and heavier shading of areas instead of lines. Try not to draw the objects in outline and then fill them in. Work from one area and let the lightest parts be the white of the paper, and the darkest areas the full weight of the pencil. Do not confuse light and dark colours with light and shade. In other words, a shadow on a light-coloured pot can be darker than the light shining on a black mug. Try to observe how light falls on an object and the shape of the shadows. Do not be misled into thinking that concentric lines across a pot will convey roundness as they may explain it but will not necessarily give a feeling of solidity.

LINEAR QUALITY Line drawing would seem to be easiest, but paradoxically, to do it well it is the most difficult. The changes in weight and thickness of the line have to convey shape, light and shade and solidity. The beginner who wants to develop this way of working might find it easier to combine line with an interest in pattern.

DETAIL, PATTERN AND TEXTURE Many artists are fascinated by surface qualities, textural or decorative. You will need to select the objects for drawing with these qualities in mind, for instance, patterned pots on a patterned cloth. The shapes of the objects and the patterns related to them will be more important in this drawing than qualities of light and shade. Beware of finding easy answers. Ways of describing different surfaces may be better done at this stage as straight forward exercises. See if you can use your pencils in ways to show the smoothness of china or the roughness of tweed, as well as to represent hair, wood, metal, and so on. You will find with some textures, like gravel and grass, you make patterns instead of using the pencil in a particular way. This is not necessarily wrong but you should know that you do it.

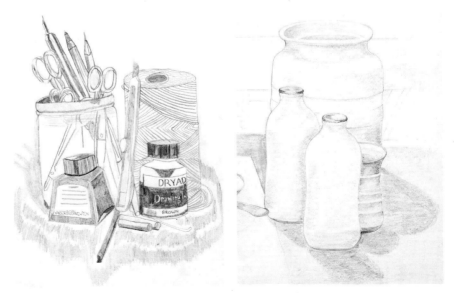

Drawings in pencil.

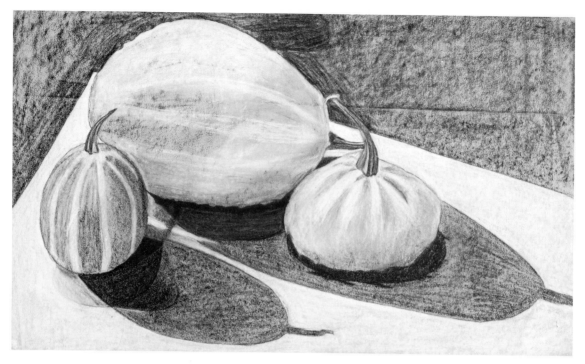

Suggestions for Further Studies

Your drawing can be developed in three ways:

● By experimenting with different materials.
● By exploring different methods of working.
● By widening the range of subject matter.

MATERIALS Most of you probably started by using pencil for the exercises and first drawings. It is possible that what you want to achieve could be done better using another drawing medium. Try doing the same subject with pencil, fibre-tip pen, charcoal or chalk, brush and paint. This will give you four very different means of approach and help you to discover which medium suits you best. When you have decided, you can build up your supplies in that area. If pencil is your choice, then increase your range of pencils to include ones that are harder or softer than those you already have, and try different surfaces of paper to work on. If you liked the fibre pen you may decide to invest in steel-nib drawing pens and Indian ink, or a technical drawing pen. Charcoal could be supplemented with chalk, conté and pastels, as well as a range of coloured papers. If you prefer to draw with paint then it would be as well to stick to the type you use for painting generally. Also, there is no reason why you should not combine two methods — pen and ink with washes of paint, pastels with paint, or pencil with pen. Sympathy with the materials you use is important.

METHODS OF WORKING When the subject matter is difficult, the way you are working and using your materials is often forgotten. It may be that your drawing is becoming tight, heavy handed, or out of sympathy with the subject

The same subject in different mediums. *Right.* Poster. *Below* Pencil (left), pen and ink line drawing (right). *Opposite page* Charcoal and chalk.

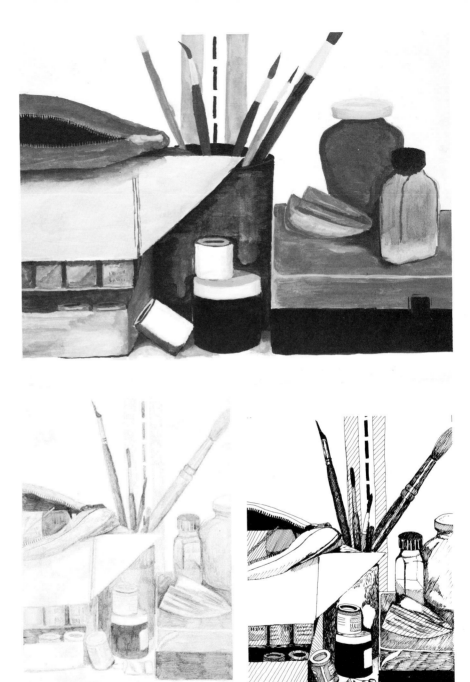

and what you want to say about it. Perhaps you should do again the exercises at the beginning on different ways of using your materials and think how they relate particularly to a drawing you have done. Possibly you should work more quickly to get more life into your drawing or, if your drawings are scrappy, inaccurate sketches, you should take more time and care. Often, a change of scale can help. Maybe you need to work on larger paper while standing up in

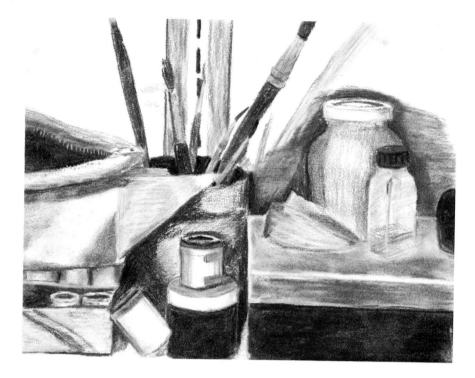

order to give you more freedom to draw. Look at books, go to galleries and study the drawings of well-known artists. They will be your best teachers and the greatest incentive to improve your own drawing.

SUBJECT MATTER Almost anything and everything can provide subject matter for drawing. At first, do not be too ambitious — limit the area to be drawn. Nothing is too difficult, it just needs approaching in the right way. Obviously, if you try to draw from memory it will be difficult, so make sure you draw from what you can see. Here are some suggestions:

Detailed studies of plants, trees, flowers.

Detailed studies of fruit and vegetables — whole and cut.

Detailed studies of man-made objects such as scissors, knives, bits of machinery, tools, an iron, a kettle, plugs, a camera, the back of a watch. You could take small areas of these and enlarge them, or view them from an unusual angle.

Detailed studies of shoes and boots, clothes on a chair, kitchen utensils, gardening tools, household cleaning materials. (Remember, it is better to draw these in a natural situation where you can relate the objects to their background, rather than contrive an illogical group in artificial surroundings.)

Quick sketches of people and animals.

Quick sketches outdoors.

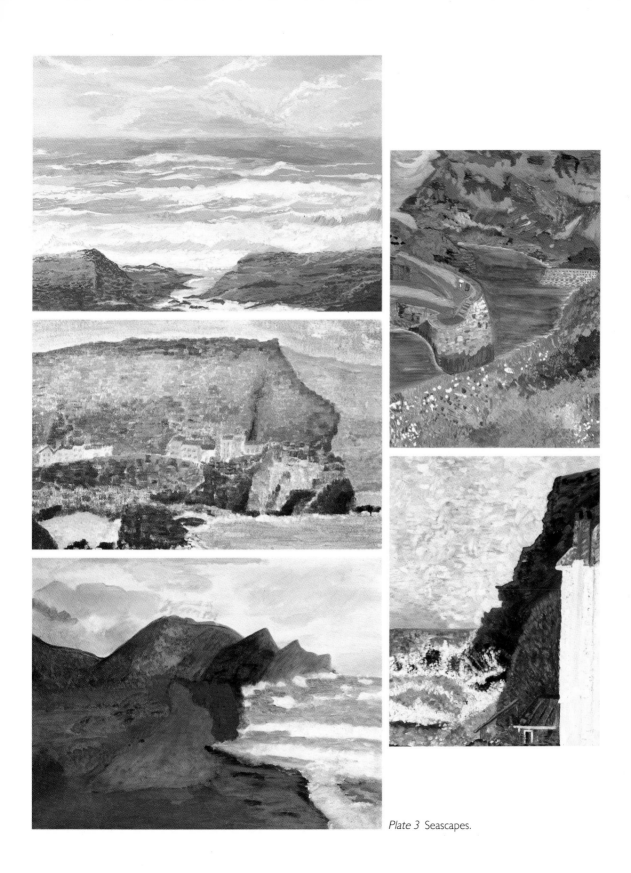

Plate 3 Seascapes.

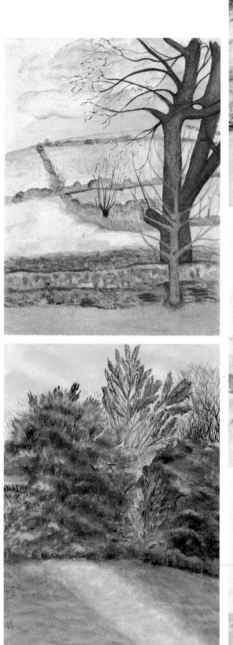

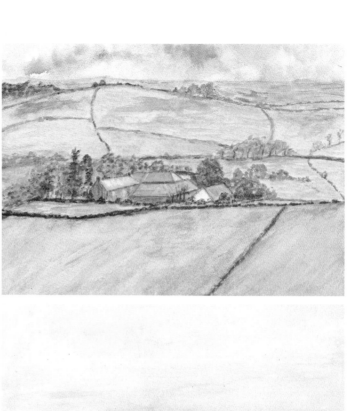

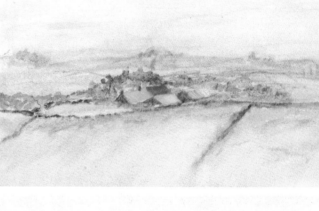

Plate 4 Landscapes.

Carefully considered drawings of people, if you can get someone to stay still for long enough. Working situations are interesting where you can relate the figure to the environment.

Working outdoors, landscape or buildings present many problems. Choose areas where you are not going to be confused by distance and perspective.

Assessing Your Progress

You will have done quite a number of drawings by now and should be able to make some sort of an assessment of your progress and decide how to go on.

If you are reasonably happy with your progress, then carry on in the ways suggested, sometimes giving more attention to materials and ways of using them, and at other times being more concerned with subject matter.

It may be that you only need a further incentive. One way is to plan a series of drawings in one medium and possibly all of a similar size. This could be combined with a study in other directions: hedgerow flowers, garden flowers, the trees in your area, windows and doorways (features of local architecture), local industry, one particular industry, life on the sea-shore, local geology, your cat or dog, your family, everyday life in the home, or outside the home.

You can learn so much more by drawing than by just reading, looking and taking photographs.

Maybe it is time you concentrated on painting, in which case your drawing may be channelled to support this.

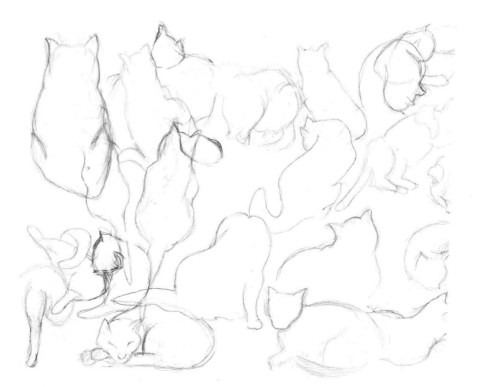

Pencil drawing.

Opposite page All are
pencil studies, except
centre left which is
charcoal and chalk.

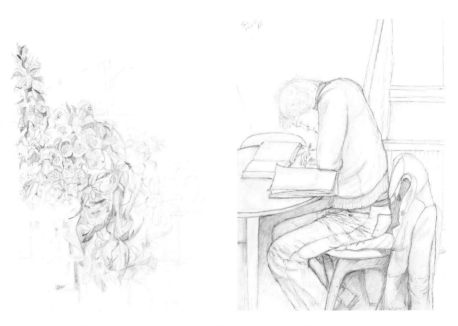

Look at the drawings and sketches of other artists. Try to appreciate what is good and sincere; learn to distinguish it from the smart work which superficially appears good or clever.

Above all, do not neglect your drawing. Drawing gives you the most direct communication with the subject – and by doing it, you learn to see and understand what you feel about what you see.

Painting

Degas said, 'Painting is not very difficult when you don't know how. But when you know how, ah! then it's a different matter.'

Experiments Using the Paint

These exercises in using the paint will seem to be very easy but they are necessary to form the basis of your style of working and your understanding of the materials and colours you use.

Set up your working area and lay out your palette. Have several sheets of rough paper for the experiments. Oil paint, if you are using it, may soak into the paper but it does not matter.

Pick up one colour on the brush and paint a small area on the paper. (Not too large — all these experiments can be done on one sheet).

Add a little water (white spirit) to the paint and put that down. Go on adding more and more water (white spirit), recording each stage until you arrive at a tinted wash.

Try rubbing the paint you have applied, with a rag, with your finger. Scrape it with a knife. Scratch it with a knife.

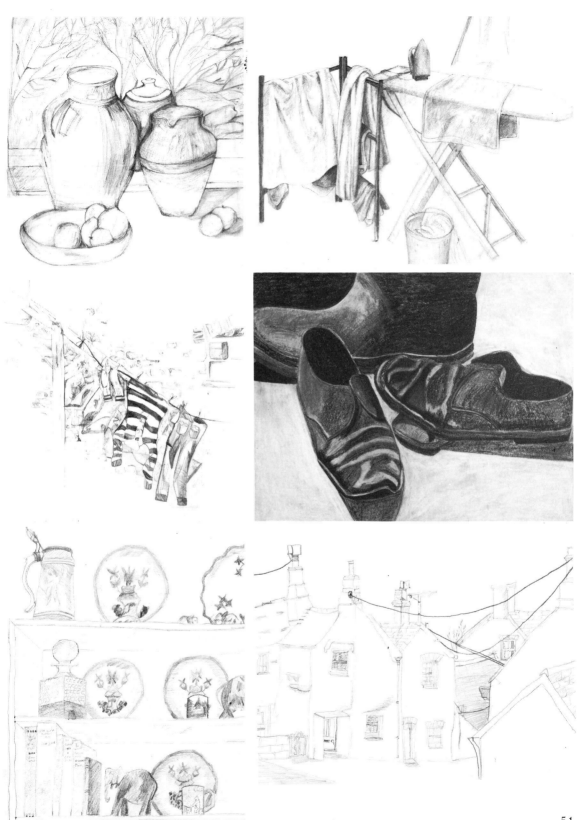

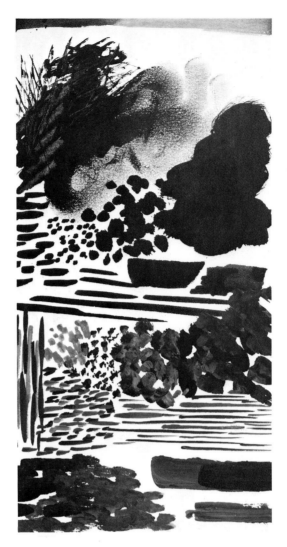

Use thicker paint and apply it in different ways: with a scrubbing action; dabbing the paint on delicately, with the tip of the brush, the flat side of the brush, the edge of the brush. Put the paint on smoothly to give a flat area, use small strokes, longer strokes, lines.

Use two colours, picking them up alternately with the same brush, and do the same actions as above. The results will be clearer using two colours.

Try applying the paint with a knife: smoothly; in dabs; scratching; scraping; laying one colour beside another; on top of another.

MIXING PAINTS Use a knife when mixing large quantities of oil or acrylic paints, as a brush will soon get clogged at the base of the bristles, will be more difficult to use and wear out more quickly.

Mix two colours thoroughly and apply to the paper in several ways.

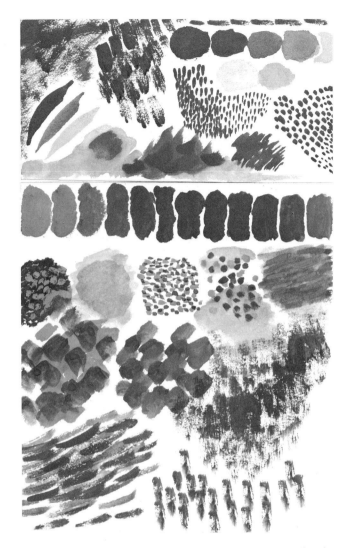

Use the same two colours, starting with one, recording it and gradually adding more and more of the other until it is entirely the second colour. Use different methods of applying the paint.

Assuming you have red, blue, yellow and white paint on your palette, work as above, mixing each colour with the others and record the results.

Mix the three colours together in varying proportions and then add white to the results.

You should realise from these experiments in mixing colours that it is possible to obtain all the colours you need, although the brilliance and intensity of some may not be as good as could be achieved by having a larger range. Later on you can buy more when you realise what you need. At the moment you will learn more by having to mix from what you have.

Choosing Your Subject

Painting is not just making pictures but learning to express something of what you feel about what you see. Do not be tempted to copy from postcards and photographs, where someone else has sorted out the problems of composition and translated what was three-dimensional onto a two-dimensional plane. Do not rely on memory as it is not very reliable and you have no means of checking.

You need to like what you paint. Try to decide what it is you like about the subject — the colour, the shapes, the textures, the rhythm — and try to emphasise in your painting what is important to you. Remember that one painting cannot say everything. Choose something to paint from what you can see. There is plenty around you — a corner in the kitchen, a window-sill, a mantelpiece, a table, by the door — all these seem to collect objects on them or near them and form a natural still-life.

At this stage it is better not to contrive a still-life. Learn to select from what you see. The area you choose may be cluttered and, if so, remove but do not add any which do not seem to belong.

Take as small an area as possible. To paint the casserole, jug and milk bottle in the corner of the kitchen you do not need the sink, shelves and cooker.

A view-finder will help you to select a pleasing composition.

A slide frame with the picture removed will do, or you can make something similar from card.

Make a rough sketch and use strips of card to help you select the composition you will paint.

Try to work with paint right away. Mix the main colours you will need, so that once you have started you can work quickly. Use the paint thinly and, by partly drawing and partly filling areas, try to get most of the paper (board) covered with approximately the right colours. Now, you will have some idea of what your picture will look like.

Next, try to get a balance of the darkest and lightest areas.

Now, correct the drawing. It is difficult for a beginner to leave the drawing until this stage. It is tempting to draw everything in outline and then fill in. Think of the development of a painting as being rather like looking through a telescope that is out of focus, and gradually as it is brought into focus objects become more and more clear. This analogy may help you to understand why you should leave the drawing until now. Also, the balance of the composition is most important and needs to be sorted out first.

Working more carefully, build up the painting from a central area, relating object to object, and objects to background. Try not to work objects separately and fill in the background later, or the painting will lose its unity.

You will have finished the painting when its problems have been resolved according to your knowledge at present.

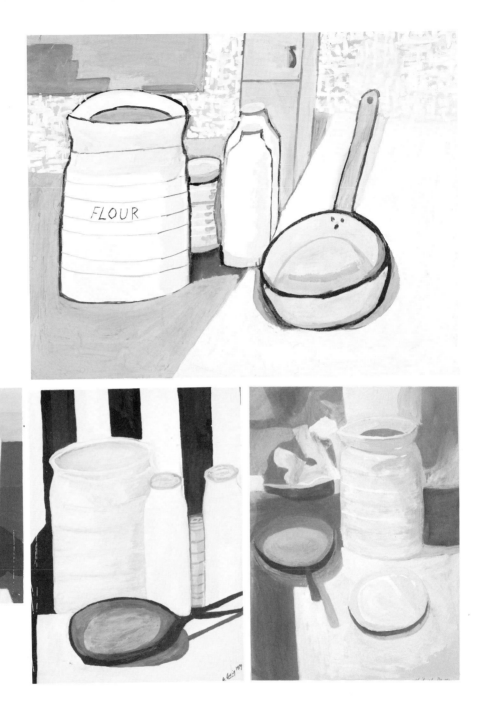

Problems

HANDLING THE PAINT

How much water (white spirit) should you use? At the start of a painting, quite a lot. You can then work more easily which gives the painting a better rhythm. You can cover the surface quickly, which allows you to consider the painting as a whole, and it is easier to wipe out mistakes. Later, it depends whether you want to build up the painting with thin layers or not. If you do, the second layer

55

should be put on dry paint. (Oil paint would have to be left for a day or so). If you want to achieve a rich texture of paint then you should use less water (white spirit) or none at all. As a rule, put thick paint over thin — the fat over the lean.

Why does the painting get muddy?

It could be the use of too much water (white spirit). It could be that you are working for too long on wet paint, so let it dry (oil paint may take two or three days). It could be the way in which you are applying the paint — if you scrub the brush into wet paint you will achieve mud! Try putting the paint on with small strokes and use dabs of thicker paint. It could be that you are a messy worker and your palette and brushes need cleaning!

Why does the painting look flat?

Perhaps you are applying the paint in the same way that you would paint a door. Use less water (white spirit) and reconsider the exercises on different ways of using the paint. Poster colours, powder colours and gouache naturally have an opaque, chalky-looking surface. If you do not like this, you could add PVA medium to the paint, or spray with poster-varnish when you finish. If oil paint is giving a similar result then you may be using it too thinly. Perhaps you should try one-third linseed oil to two-thirds of white spirit as a painting medium.

COLOUR

The painting is too bright!

Assuming you are using a palette of red, blue, yellow and white, you are possibly not giving enough attention to the mixing of colours. For instance, brown will be warmer, or darker, or lighter, depending on how much red, blue, and yellow you use. It could be that for you green is a straight fifty-fifty mix of yellow and blue. Try varying the proportions, adding white or a touch of red. An object that is yellow will not appear yellow all over. Light shining on one side will cast shadows on the other, the yellow of the object will change from light to dark.

Would it not be easier to buy more colours?

If you did this you would have more choice and would save time on mixing but you would not learn to understand the basic principles of colour. If you used a larger range of colours, your painting would have very little colour harmony unless you really understood which made what. This you will learn by using a restricted palette.

The painting lacks harmony or unity of colour.

It could be too many colours, for instance, three primaries fighting each other, or the distribution of colour in the picture. At the start try to assess the main colours of your subject, such as brown, orange and blue. The blue you have, mix the orange and the brown and, while you are working, try to stop yourself using pure red and pure yellow; only add them to alter the main colours you are using. It does help to cut out the use of one, if not two, primary colours straight from the tube when you want to achieve more harmonious results.

Look at the distribution of each of your main colours. It could be that all the warm colours are on one side and the cool colours on the other. One colour may occur once only and have too much impact in isolation. One colour may dominate the painting. Do not be afraid to change things.

COMPOSITION

The painting doesn't look right!

Perhaps it just needs a little trimming. Put strips of card around the painting, then move them up or down, in or out until you have the right balance. (You may need a second opinion.) If paper, cut it, if hardboard, saw off the offending piece!

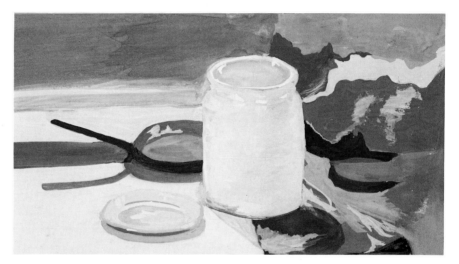

Poster painting. *Below:* the same painting trimmed.

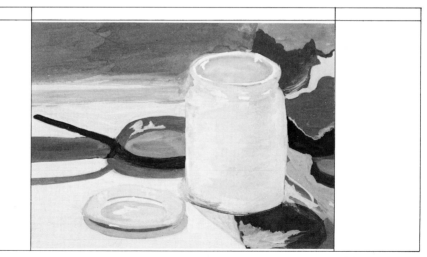

The mistake may be fundamental, in which case you will have to learn by the experience. The subject may be falling off the bottom, or look like a photograph that missed! There is no solution, except that next time you will prepare more carefully.

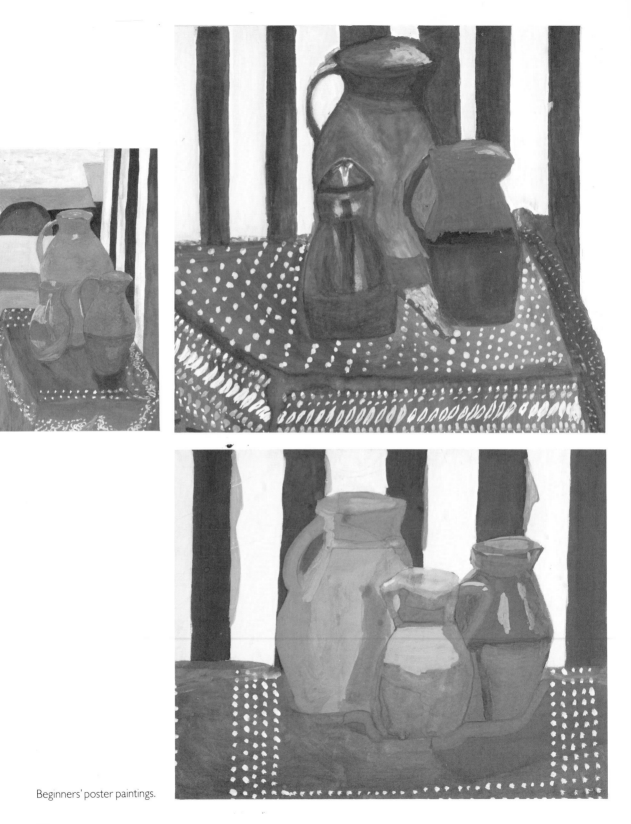

Beginners' poster paintings.

The objects look unbalanced.
All the tall things are on one side, or it is too symmetrical, too spaced out, or too crowded. This should have been solved at the beginning. You could rearrange the objects or just change your view-point.

There seems to be no focal point or rhythm.
Your eye wanders over the painting with no purpose or guidance. This is one of the most difficult things to understand and put into practice. Concentrating on one focal point, not necessarily the middle, is easier. The painting can grow from this area, move away from it, but keep returning to it. Always keep objects and background related, literally, by painting one in conjunction with the other. Rhythm is obtained when two or three points are obviously linked so that your eye knows which way to travel across or around the painting.

Look at the work of well-known painters. Try tracing off the main lines and curves of construction of one or two. Try to assess and understand what it is that makes theirs look and feel right.

Subject Matter and Suggestions
How do you decide what to paint next? Ideas may come from two sources. You may have seen something you would like to paint, in which case, do it. On the other hand, you may realise an obvious gap in your knowledge and need a particular exercise to learn about it. There is no reason why you should not combine the two. The next few paintings could be of similar subjects treated in different ways, or very different subjects concentrating on one or two techniques.

The basic techniques you should be considering are:

● Different methods of applying the paint
● Mixing the colours and restricting them
● Light and shade
● Balancing the composition:
 Foreground to background
 Shapes to each other
 Colour to shapes and the whole
 Focus and rhythm

The subject matter you consider will lie within these areas:
 Still-life, Interiors, Flowers
 Landscape and Buildings
 Figure Compositions

These are dealt with separately in the next three chapters, but before you commit yourself to one of those sections, you should do several paintings in the ways suggested here. They will help you to decide which area interests you most. You need not stick rigidly to the combinations of subject matter and techniques suggested but they should provide a framework if you have other ideas.

Needless to say, find your own subject matter and avoid using photographs.

A window-sill with a large pot and a bowl of fruit — balancing the composition.
Consider the arrangement before you start. Is it too symmetrical? Could more shapes overlap each other? How do the lines of the window-sill relate to the objects on it? Should you use a taller or larger pot? Have you thought about the distribution of colours? Can you reduce the number of colours?

Do a quick sketch to see how it looks on paper. Then use strips of card around the sketch to decide the position of the objects and how much of the background you will include. This is the time to rearrange the objects, if necessary.

Paint your picture keeping in mind the relationship of object to object, and objects to the background.

A bowl of flowers on the mantlepiece — using the brush with small strokes or dabs of paint.
Decide on the colours you will use — not too many — and if possible cut out the use of one primary colour except for mixing. Have your colours and mixes ready on your palette in reasonable quantities so you can work quickly.

Do a quick sketch with thin paint, blocking in the main areas of colour. Let it dry. If you are using oil paint then rub with a rag to speed it up.

Apply the paint in dabs of colour to flowers, pot and background alike. Textured flowers and a washy background will not relate.

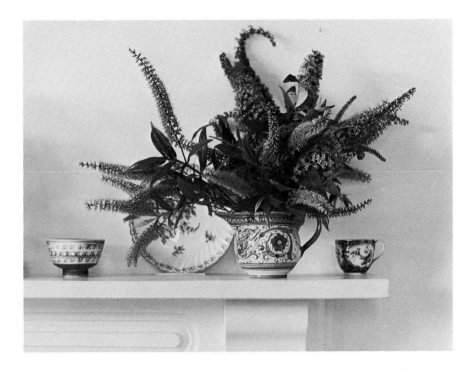

Look for the masses of colour, the light and shade, and do not worry too much about the details of individual flowers and leaves. It may help to move further away or reduce the lighting. If your work is getting sticky or messy use less or no water (white spirit); try a palette knife, or let the work dry before you continue.

Landscape the view from your garden or window — restricting the colours.
Do not be too ambitious. Restrict your view as much as possible to a bit of grass, a few flowers and shrubs with not much distance. Use a view-finder to help you select your composition.

Do a couple of quick pencil sketches and decide which composition is best.

Lay out your palette, mixing several greens, greys and browns. Depending upon what is in front of you, cut out the use of two primary colours and only use them for mixing.

Work quickly – light changes the appearance of landscape. Detailed work and relating the colours can be done later.

Figure sitting at a table — relating the main subject to the subsidiary subjects and background.
This provides problems enough without having to worry about colour. Use two only — one primary and one mixed, e.g. blue and brown, and white.

Do a couple of quick drawings to decide the composition.

61

Using thin paint, block in the main areas to get the composition established. Do not worry about details at this stage. It is tempting to start with the face as this seems the most difficult. Do not worry about the face — you are not painting a portrait. Try to relate the figure to the chair and the table right from the start, and not one by one hoping they will relate when you have finished. For instance, start from the elbow on the table and work a little way across the table to the objects on it. Then go back to the elbow and work up the sleeve to the collar. Go back to the elbow and work down to the chair. In this way you will be assessing small distances only and not trying to estimate the entire proportions of the figure.

Remember that your subject will not want to sit still for very long. You may need to do separate drawings of details to help you complete your painting later. By making the background as important as the figure you should be able to complete your painting with intermittent sittings from your subject and with your drawings.

Your front door — as the focal point of your painting.
Painting a picture of the whole house or the street is as formidable as it would be to paint it literally! Problems of composition and perspective are too much at the beginning stage. It would be better to focus on one aspect, e.g. your front door. If there are flowers around it, milk bottles on the step, and the door is open so that you can see inside, then these things will all add to the interest of your composition.

Use a view-finder to decide what would be suitable and do a quick sketch to make sure.

Again, use a restricted palette. Put down the main areas of the composition with thin paint. If you are aiming to focus the spectator's attention on the open door, for instance, start there and let the painting grow from that area, with more detail in the painting at that point than away from it. You should get the feeling of being drawn in if you are successful.

A way to realise this is to concentrate your attention on the opening of the door and decide how much, or little, colour and detail you can see in the areas that surround it. You will probably have an impression of colour and shape but not much detail. Try to convey this sort of impression in your painting.

Corner of the kitchen, sitting room or bedroom — light and shade.
Arrange the lighting to cast strong shadows, so that some objects are very clear and others disappear into the background.

Do a quick sketch to decide the composition.

Restrict your palette but make sure you can match the darkest and lightest areas. Using thin paint, block in the main areas of the composition, establishing the lightest and darkest areas.

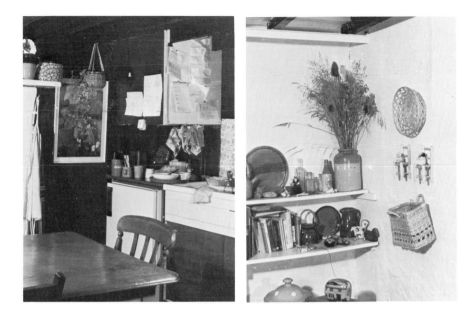

Use thicker paint and try to relate object to object and objects to background, being particularly aware of the colours needed for the lighter areas and those for shadows. Remember that light is not necessarily white, nor shadows black.

Assessing Your Progress

You are at a stage now when you can make some sort of an assessment of your progress.

- You have painted several pictures.
- You know how to mix your paints and apply them.
- You know which colours make what.
- You know how to go about making a satisfactory composition.
- How should you go on from here?

If you are reasonably happy with your progress, then continue painting pictures by setting yourself tasks similar to the suggestions linking subjects and techniques. Beware the self-indulgence of painting as a therapy — after each painting you should feel that you have learned something.

You may not be satisfied with the development of your painting because you are conscious of the obvious gaps in your knowledge. It is necessary to analyse these and make suggestions as to how to deal with them.

DRAWING This is likely to be at the root of your dissatisfaction. Good drawing is evident in good painting and you need the skill to help you express what you see. Drawing is learned by drawing, so work from the section on drawing but do not altogether neglect your painting.

MATERIALS Maybe it is time you had a good look at what you are using.

Oil on paper.

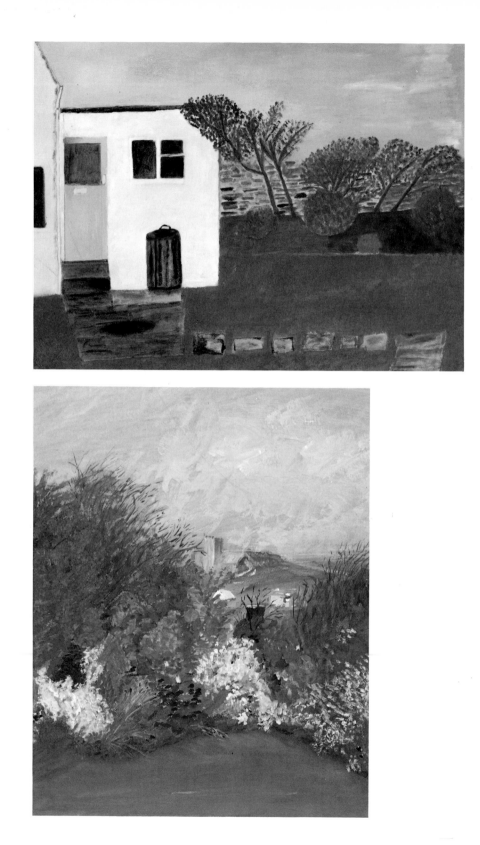

Poster paint.

Plate 5 Landscapes.

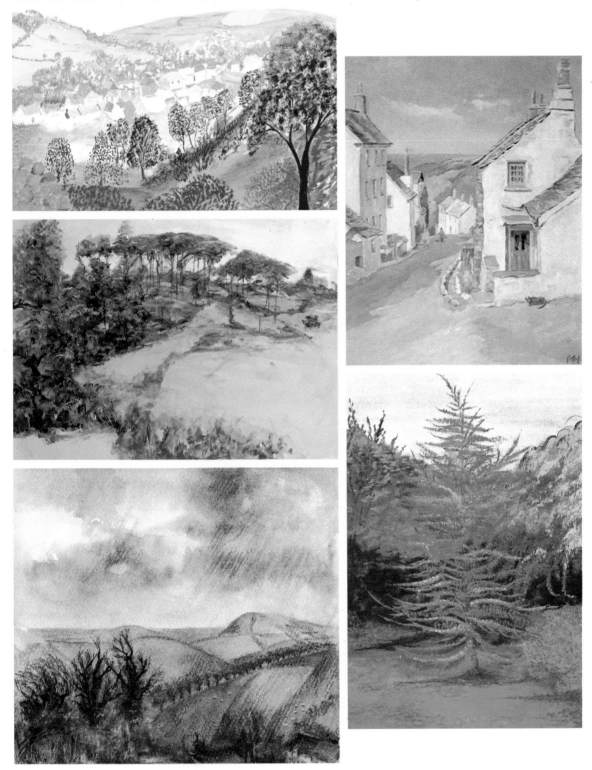

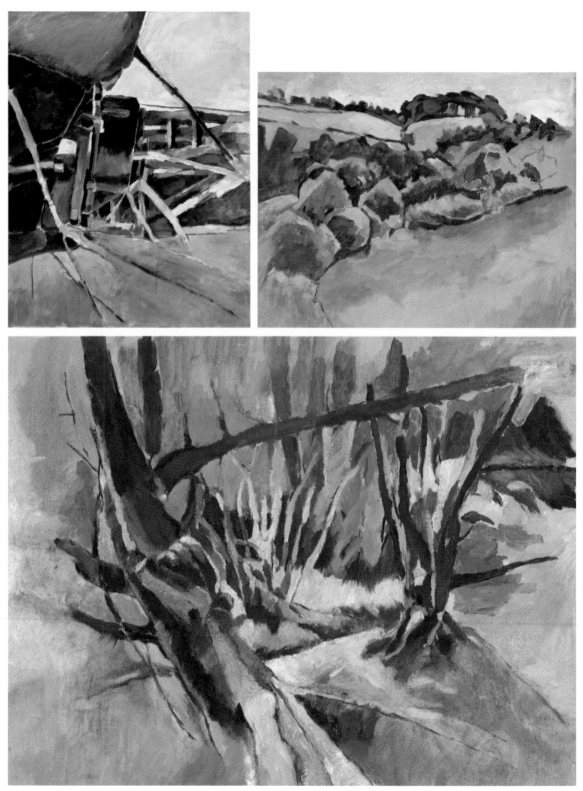

Plate 6 Landscapes.

Poster paint.

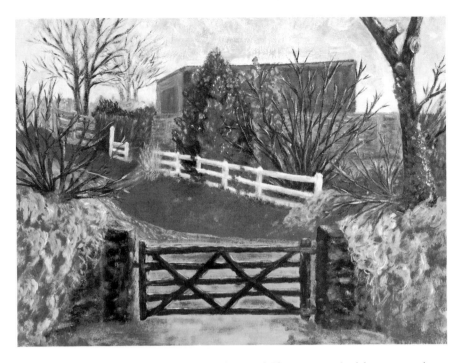

Are you using the right sort of paints for you? If you started with poster paints, perhaps it is time you changed to oil, gouache, or acrylic. Re-read that section to help you decide. You may find the number of colours you have too limiting and you may need to increase the basic range, so consult the lists in the first chapter and buy a few more.

Do you need new brushes? You may need a larger range of sizes and another shape may suit you better.

Do you like the surface you are working on? If you are finding hardboard slippery, change to sundeala, or try glueing butter muslin to hardboard, or use paper or cardboard.

Is it becoming expensive using boards? Sized paper is a lot cheaper.

Are you working on the right scale for you? Very often people work small to be economical. Try different sizes of board or paper to find out which suits you best.

DEVELOPMENT Is it time you understood more about the following?

- Colour and light, tone, line and shape, patterns and textures and composition?
- The history of painting and the way artists work?
- Landscape painting?
- Still-life and interiors?
- Figure compositions?

How to decide? You cannot do everything at once. Doing a bit from one section and a bit from another is going to muddle you. You should make a programme of work — vague in the long term but specific over a period of months. Some aspects will never concern you but others will be developed to the limit of your ability.

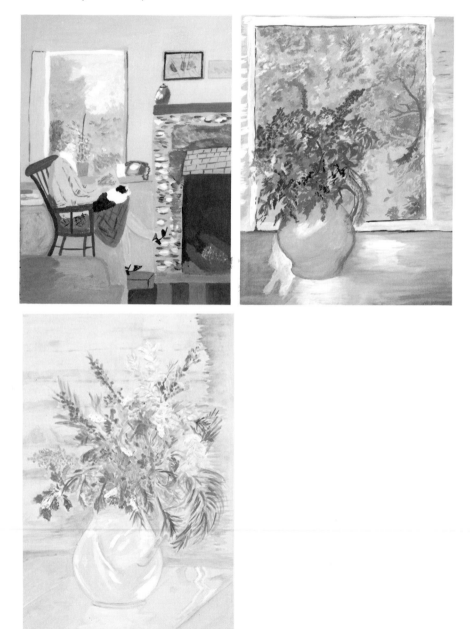

Poster paintings.

Chapter 3
Working Outdoors

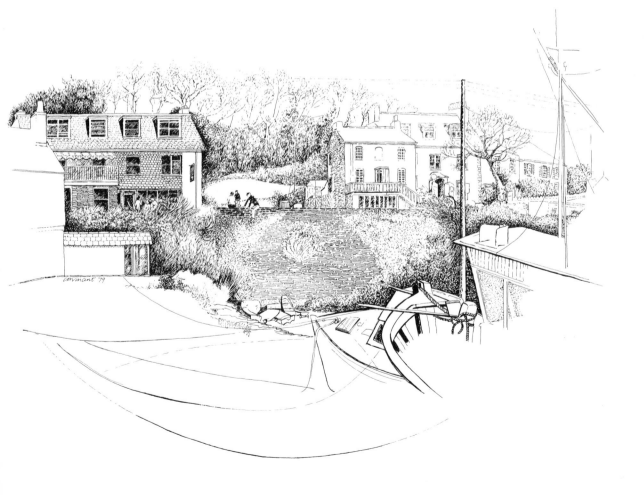

Painting and drawing outdoors is pleasurable, challenging, exciting *and* frustrating. The great tradition of landscape painting is a stimulus few painters can ignore. It is pleasant to work in the open and a challenge to record changes of mood and colour — exciting if you succeed and frustrating when you do not. Many things can go wrong. The cause, very often, is lack of preparation and anticipation of what may happen, such as taking too much to carry; forgetting the paints, the water, something to sit on, or a thermos of tea; sitting where passers-by can peer over your shoulder; or forgetting that the sun moves and that it might rain. Sometimes your best retreat is the car. It can make a very good, secluded studio, once you have organised yourself to work in it.

Do not be tempted, in spite of the hazards, to replace this experience by working from photographs. The camera has its uses but does not replace a sketch book. Used wisely, photographs can help, and a very experienced artist may use them exclusively, but you should be recording what you see in a way which will be entirely your own.

Materials and Equipment

To work outdoors, good organisation of materials and equipment is essential. Take as little as possible in something that is easy to carry, like a basket or haversack. An easel, if you take one, needs to be light and sturdy, but on breezy days it is as difficult to control as a sailing boat! Manage on your knees, and remember to take something to sit on.

Oil Painting and Acrylic

- Three or four brushes — various sizes, palette knife
- Palette
- Bottle of white spirit for oil painting
- Bottle of water for acrylic and retarder — acrylics dry very quickly outdoors
- Two jars

- Board or stretched and sized paper, or canvas. Canvas needs cardboard across the back if you are going to work on your knees. Think how you will carry a wet board: two boards can be kept apart by canvas pins which you can

buy, or make your own arrangement with a thin piece of cork and drawing pins going through each way. Drawing board clips will also do.

- Sketch book or scribbling paper and pencil
- View-finder

- Paints Have a range of Cadmium Red, Lemon Yellow, Cobalt and White, so that if you forget anything else you can manage. Another red, yellow and blue would be useful, e.g. Crimson, Cadmium Yellow and Cerulean and/or the earth colours, if you like them. If you know where you will be working, you can select your colours before you go so that you do not have too much to carry.

**Gouache,
Watercolours and
Poster Colours**

- Three or four brushes. Have at least one large brush.
- Plate for mixing, plus plastic tubs or ice-cube tray for holding larger quantities of thin paint.
- Bottle of water
- Jar
- A couple of boards with stretched paper, or board prepared on both sides.
- A sketch book or scribbling paper and pencil.
- View-finder

- Paints Make sure your range includes Cadmium Red (Brilliant Red or Vermilion), Lemon Yellow, Cobalt and White so that you could manage if you forget one of your favourite colours.

**Drawing and
Pastels**

- Paper Plenty of it in a size and quality suitable for the medium, e.g.
— for pencil, A3, A4 or A5 student's cartridge, or a heavier paper.
— for pen, A4 or A5 smooth card or paper.
— for charcoal or pastels, A2, A3 or A4 sugar paper, or similar coloured paper.
If in sketch book form, make sure it can be folded back. If loose sheets on a board, you will need clips, drawing pins or tape.

- Putty Rubber
- View-finder

- Pencils B, 2B and 4B and sharpening knife, or
- Drawing pens and ink — not very good in very hot weather, or
- Fibre-tipped pens, thin and thick — some can be brushed with water to give a half tone, or
- Coloured drawing pencils, or
- Charcoal and Chalk, Conté or
- Pastels, soft, or oil — take a good range, but be selective in use.

Choosing Your Subject

You will have decided roughly where you want to go. Wander around with your view-finder to find a good spot to work from. A comfortable place, out of the wind and away from the view of spectators will probably suit you. Selecting your composition from what you can see is difficult.

The instinctive reaction seems to be to take in all you can see, but you should train yourself to consider the possibilities of selecting only a small part. Look at this photograph. You would need weeks to do justice to such a complex composition, attractive as it may be. Taking a small part of it, and there are many areas you could select, can give a feeling of the whole. The very fact that you are on the spot will influence the colours you choose and the way you put down what you see. Use your view-finder to find the area you would like to concentrate on and do a quick pencil sketch. Consider the balance of the main shapes and areas; the horizon — how much sky is there in proportion to the area of land? Does it need a tree or building to break the line of the horizon and if so, where? You may need to change your focus slightly. When you are satisfied that you have a reasonable composition you will be ready to start.

Dingle, Ireland.

70

Drawing and Pastels

Get down the main areas of the composition lightly and be particularly aware of the lines linking one area to another. Let your drawing grow from the focal point, or main line of rhythm, establishing the dark and light areas as you work. Do not jump from one part to another and hope all will link up in the end.

If you are using colours, select as few as possible and think about their distribution on the paper. Very often coloured landscapes finish up looking like flags, with bands of blue, green and yellow. Is it possible to use some of the foreground colour in the sky? If you do not have exactly the right colour, use one that is similar. Constantly adding new colours to your initial selection will destroy the unity of your picture. Carry on until you have shown what it was you liked in the first place.

Development of Drawing

Basically, artists are concerned with learning to see and to record the essence of what they see. In the early stages, accuracy is the most worrying, and outdoors the problems of perspective seem to be the most formidable. You may probably have memories of technical drawings showing railway lines, telegraph poles and streets disappearing into the distance, and cubes with lines converging on vanishing points. None of this is very helpful when you are confronted by a street of old houses set at different angles, going downhill. You may need this technical knowledge to work from memory but on the spot there are a few rules of thumb which would help you to make a fair drawing.

Use your view-finder to select the composition.

Make sure you are sitting comfortably and can see what you want to draw by raising your eyes from the paper, not by moving your head.

Make a very light, rough sketch of the composition and take a good, critical view of it. You cannot solve any problems until you have a record of what they are. What is it that you find difficult? Very likely, it is not knowing what to look for.

These photographs and drawings may help you to understand.

Three facts should be apparent:
1 Things appear to get smaller as they recede into the distance.
2 Vertical lines remain vertical, unless you are looking at skyscrapers in New York.
3 It is the horizontal lines that change their angles dramatically.

The only aid you need is your pencil which can be held horizontally and at right angles to your body to check the angles, and at arm's length to measure distances. *See pages 42-44.*

Start somewhere near the middle with one building you can see clearly. This will be your reference point. Draw the vertical corner line on your paper.

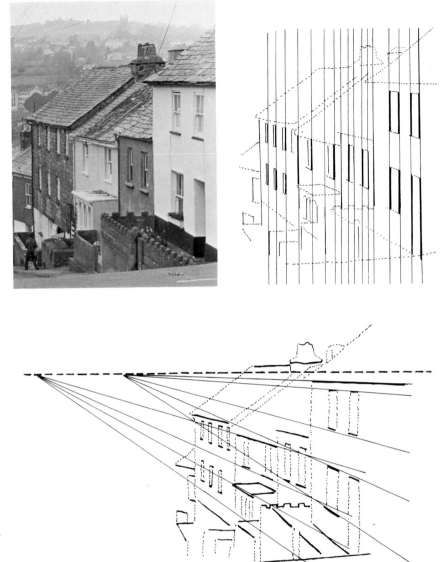

The two houses are at slightly different angles to the road which accounts for the two vanishing points.

Hold your pencil horizontally, on a level with the top of the wall. Does the guttering line go up or down, and if so by how much? Put it down but do not determine its length at this stage.

Go back to the corner line near the top and judge by eye the vertical line of the top window. The line of the lintel will not be far off that of the guttering but the sill line will need checking for its angle.

The width of the window should be compared with the distance from the corner to the window by using your pencil at arm's length as a measure. Also check the height of the window compared with its width.

Continue in this way, occasionally making cross references by measuring distances between buildings, checking what is level with what, taking comparative sizes into account, e.g. the doorway near to you may be bigger on your drawing than the church in the distance.

This method of working has been stated before: let your drawing grow from one area and relate everything else to it. Boats, trees and plants may seem, at first, to be as formidable as buildings but by careful selection when you start, taking a small area and developing from that, you will find that your drawing will improve.

Suggestions for further working:

Take a subject idea and combine it with a method of working. The permutations will keep you going for a long time. Try to work in series or themes, letting one piece of work develop naturally from the other. In this way, you will be able to study your progress; you will learn to see and to know quite a lot about what you see.

Subject Ideas

Chimney pots, roof-tops, doorways, windows.

Alley-ways, back streets, looking up the street, down the street.

Different types of buildings: old cottages, Victorian terraces, Georgian houses, farmyard buildings, shops, factories, churches.

Looking at buildings: over a wall, through an archway or gateway, through railings, through or behind trees or plants.

Plants growing around a door, on a wall, against a wall.

Looking at a hedge, or through a hedge.

Trees: parts of trees, groups of trees, trees in summer, in winter, or dividing the landscape.

Bridges, harbours, boats afloat or on the sand, barges, cargo boats, the quay-side.

Quarries, mines, rocks.

Water: pools, puddles, streams, rivers, the sea.

Textures and patterns of walls, of plants, or moving water.

Change of light and atmosphere in different weathers, times of the day, times of the year.

Methods of Working

Quick sketching for essential movement, rhythm, and structure.

Working in line only.

Using light and shade only, with no lines.

Looking for texture and pattern.

Only record horizontal or vertical lines.

Only record shaded areas.

Only record the spaces in between what is beyond.

Detail of a wreck.

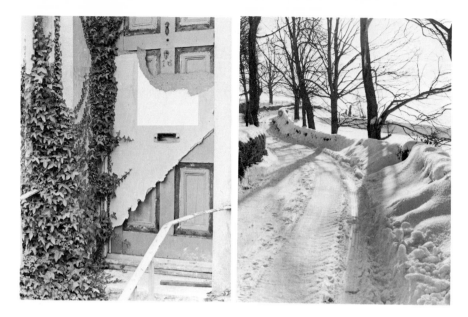

Use different pencils, pens, charcoal, conté, pastels, pen and wash, or brush and wash.

Work on different surfaces and different sizes.

Enlarge small areas.

Make detailed studies.

These two lists are by no means complete. Add your own ideas to them. Make a work programme for yourself, using what is necessary for your own development.

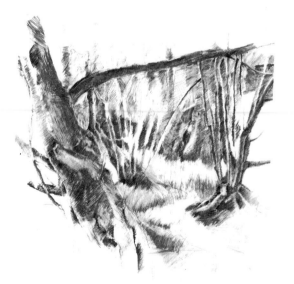

Pencil drawing.

Opposite page Drawings in line or tone. *Top* Pen and ink. *Centre* (l. to r.) Pencil, felt-tip, pencil. *Below* Conte, pencil.

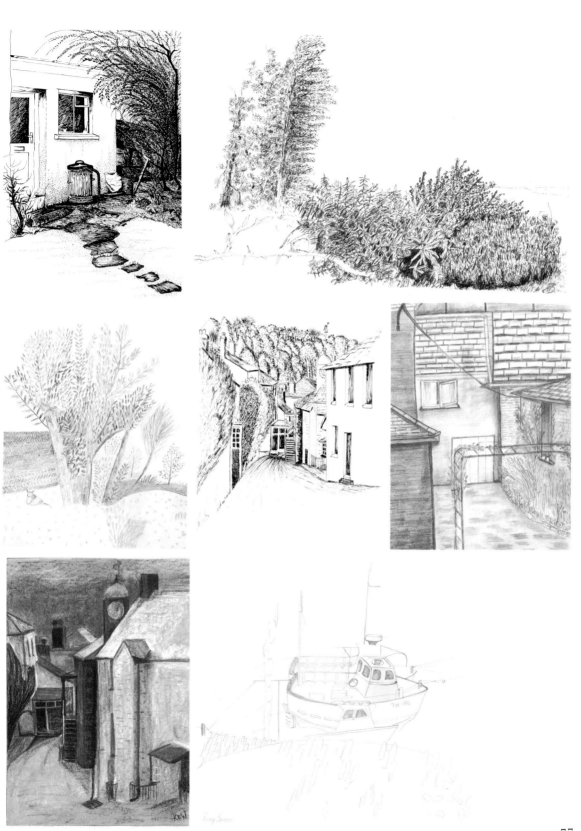

Painting

Lay out your palette using as few colours as possible.

Put down the main areas of the composition in thin paint. Light changes the appearance of things very quickly outdoors, so you will need to work quickly to establish the colours, the light and dark areas.

Detailed drawing can be left until later.

Get one area resolved with the right balance of colours so that if you have to finish the painting at home, or in a completely different light, you have a satisfactory reference area.

After two or three hours, stop to ask yourself whether you have enough information to complete your painting if it rains or you have to go home. Make drawing notes on your first pencil sketch and colour notes on your painting.

Remember you cannot say everything in one piece of work. Try to concentrate on one aspect, e.g. colour and light, or movement, or pattern and texture, and let it be evident.

You may find that you can go on working outdoors for several months or years, trying differing subjects, using different colours and techniques, experimenting with other mediums, and improving your drawing, without any further technical help. You will realise when you do need help, at times when inspiration is lacking and you just do not go out to paint, or when you feel you are not making the progress you ought to be making.

Subject Ideas

See the list of suggestions in the drawing section.

Oil on paper.

Opposite page Top Oil on card. *Below* (l. to r.) Acrylic, gouache, oil.

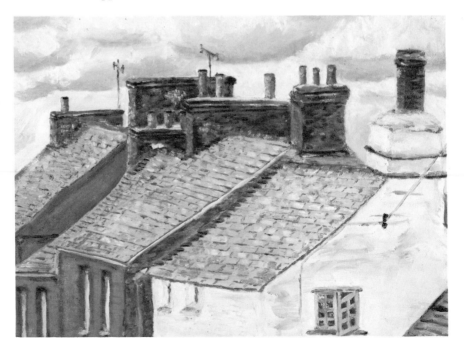

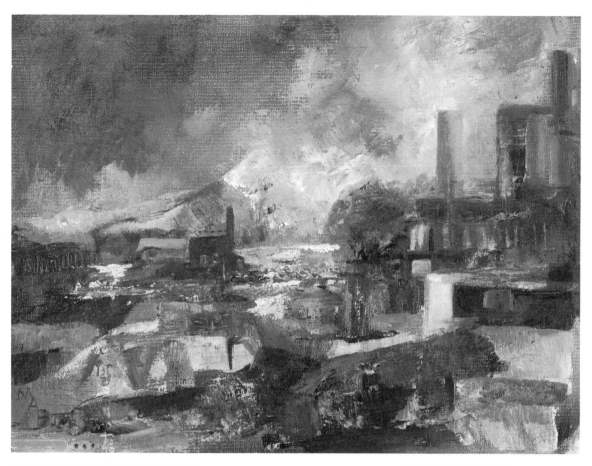

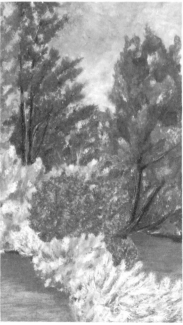

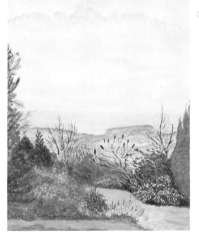

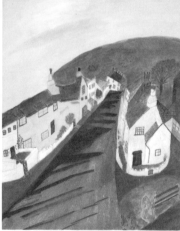

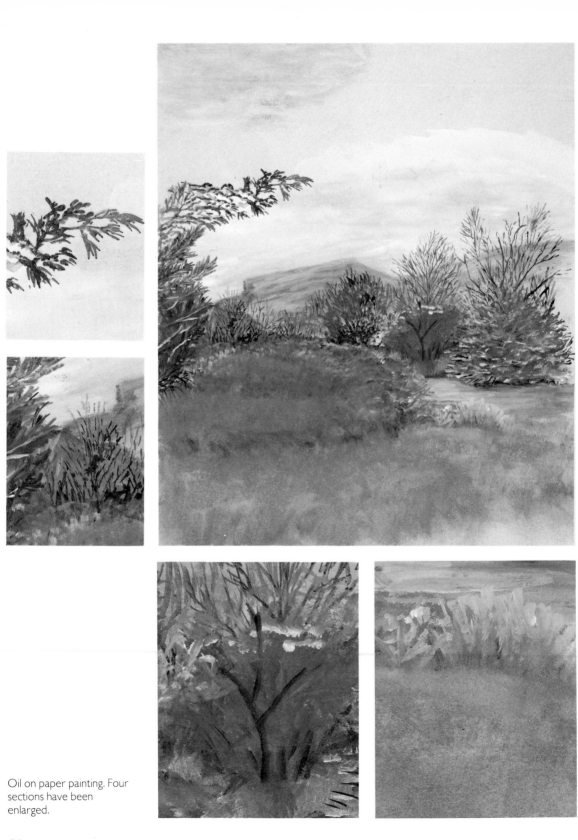

Oil on paper painting. Four
sections have been
enlarged.

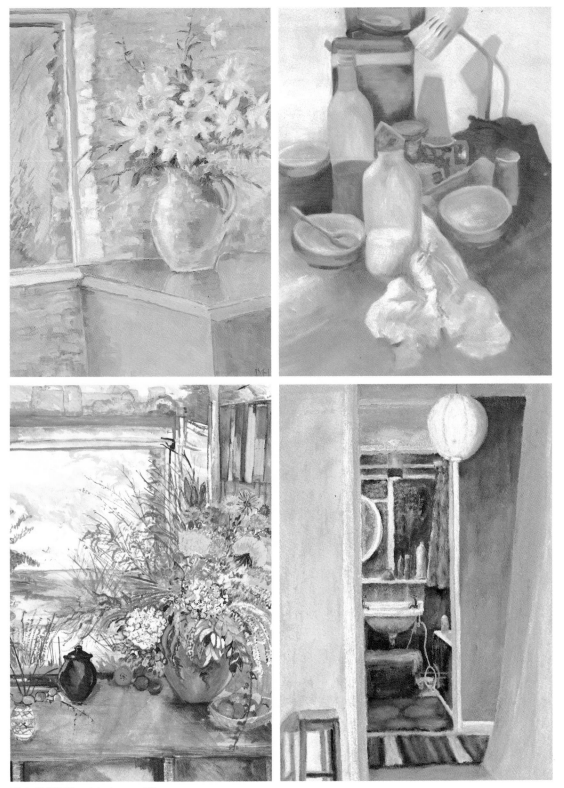

Plate 7 Still-life—interiors and flowers.

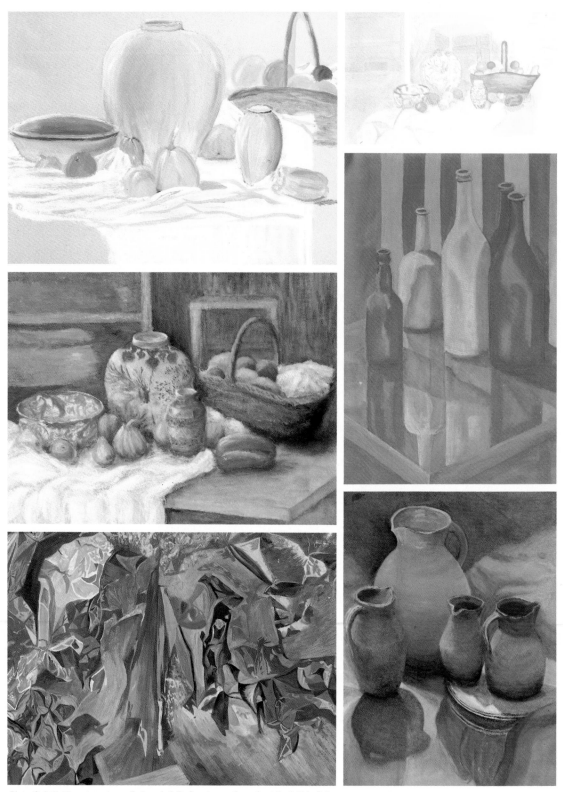

Plate 8 Still-life—interiors. *Below left* Reflections of an electric drill in foil.

| **Development of Painting** | If you want to develop your studies of landscape painting you will need to be able to work indoors. This has its problems, especially for one who prefers the direct contact with the subject being painted. If you tend to formalise your work, then being away from the subject can be an advantage. It will be necessary to find some way of developing sketches if you want to work at landscape on rainy days and during the winter. Working indoors should provide you with a new experience and not be an attempt at a repeat performance to recall sunny days. |

Three possible ways of working will be considered:
1 Completing, at home, a painting started outdoors.
2 Working from drawings and sketches in another medium.
3 Analysing drawings and sketches in different ways.

| **Development of Landscape Sketches Indoors** | The advantage of working on the spot is that you record your reactions spontaneously. You can feel the atmosphere, the rhythm and movement. Working away from the subject allows you to consider and organise these spontaneous reactions. |

COMPOSITION is very difficult. You probably know when it is wrong but do not know how to put it right. Some things are obvious — too much sky, too little sky. Sometimes the division is definite and therefore must be in the right place. Use strips of card around your painting and vary the proportions of sky to land to decide which is best. When you are sure, then you can cut off the offending piece.

You must consider the relationship and balance of the most significant objects and areas. How does your eye travel across or around your painting? Is all the interest at the bottom and, if so, can you find some way of leading the eye upwards? Perhaps a tree or group of buildings could be emphasised further up, or exaggerated to break the horizon.

DRAWING You will depend upon the information you have brought home with you. If it is inadequate you will have to return to the scene and make further studies. Consider the detail in the areas that need it and correct and develop where necessary. *See* drawing *page 82.*

COLOUR AND TONE are closely linked and whether the painting is too dark or too light will depend upon the colours you have used. Two major problems which may occur concern the sky and large areas of green. The sky is likely to be blue or grey, light in tone and cool in colour, which can make it appear to recede. Areas of green, if you are not careful, will be middle to dark in tone, and green mixed from yellow and blue is neutral. Achieving a balance between these two is very difficult. Is it possible to introduce some colour from the foreground into the colour of the sky or clouds? A straight mix of blue and yellow does produce a darkish green, so try using far less blue, or a different blue, and experiment with different yellows and touches of red. Try different ways of

The first sketch on the left was inadequate for development. The much improved drawing on the right provided enough information for several paintings.

applying the paint. Look at each of the colours you have used and consider their distribution in your painting. Are any of them isolated in one area only? If so, you could replace it with another colour you have used that is similar in tone. How have you balanced the warm and the cool colours? How have you coped with the shadows? Take care that the shaded areas do not make your painting too heavy.

Have you achieved a feeling of distance? Look at any landscape and find out what it is that makes objects look near or far away. It is not only a question of scale, so what happens to colours, to tone and to detail?

TEXTURE Are you happy with the way you are applying the paint? Has the painting become heavy and muddy because of your technique? Maybe you should let the paint dry and then overpaint, or scrape off areas and repaint, or use a different method of applying the paint. Is your technique consistent and, if not, does it matter? Large areas of thin paint, with a few thickly-textured trees dotted about, may look odd. Van Gogh painted the sky with the same vigorous strokes he used for fields and trees. Where you do change your methods, make sure it is for a good purpose, otherwise it may be safer to be consistent.

All these aspects of your painting can be studied objectively away from the subject. You may find that you did not collect enough information, in which case you may have to go back and, very likely, it is the drawing that will send you back. However, if you can learn to work in this way, you will increase your range of subject matter considerably, as you can take advantage of day trips to new places, holidays, and sudden and dramatic changes in the weather.

Working from Drawings or Sketches in another medium.

If you paint in oils or acrylics you may not want to take all the necessary equipment with you. You may prefer to carry a sketch book and pencil and some easy means such as pastels or crayons of recording colour. If you want to develop these sketches into paintings later on, the information must be

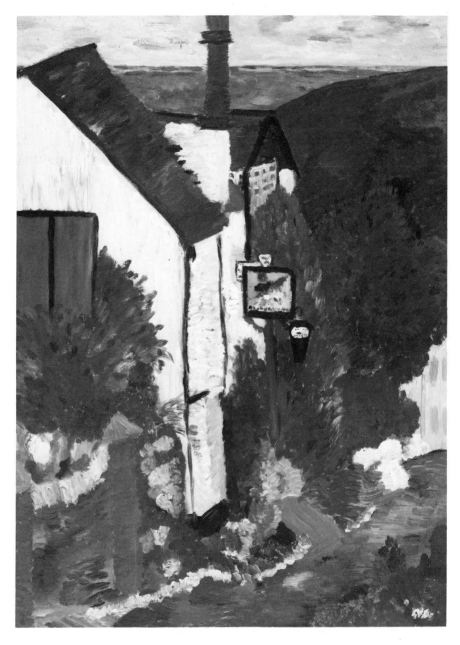

adequate. It is no good expecting to work from piles of sketches that give nothing more than vague impressions. It would be wiser to do one detailed drawing and a few quick colour sketches of the subject that interests you.

At home, look at your sketches and select those which are possible for development. Try this way of working from them:

Decide which medium you will use.

Use strips of card around your sketch to find a satisfactory composition.

Make sure that your board, canvas or paper is in the same proportion as the sketch.

Select your colours — as few as possible — and mix the main ones you will need.

Work from your sketches in the same way that you would work from the subject itself. Consider the balance of the composition, the drawing, colour, tone and texture as explained before.

Top Pencil (left). Poster (right). *Below* Pencil (left). Gouache (right).

Opposite page (l. to r.) Pencil, pen, gouache.

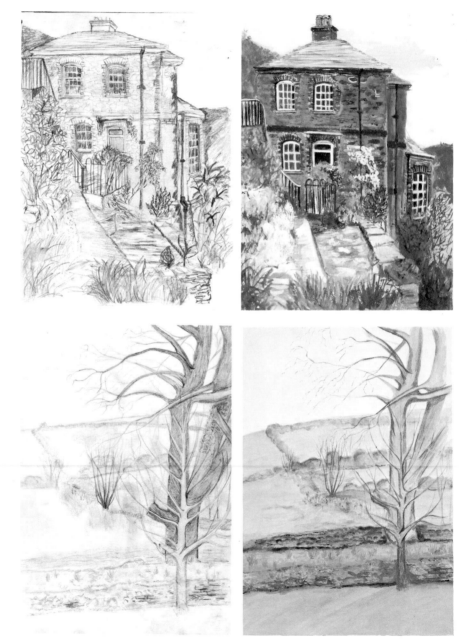

What have you achieved? Is your painting just a repeat performance on a larger scale, with the inadequacies of the sketches made more obvious? If the answer is yes, then what went wrong? It could be that your sketches lacked the information you needed or it could be that you had nothing new to say. Lack of information is easily remedied for you will know next time to take more trouble. Saying something new is more difficult to assess and to solve. You need to be quite clear in your own mind what it is you want to say about the subject you chose to paint. What is most important? The colour, the effect of light, the relationship of the shapes, the feeling of distance or going through, the rhythm and movement, the texture of the paint. If you know what it is, then all other factors can be subordinate to this. You may need to change the scale of your work and possibly go some way along the path to abstraction, taking out all that is not necessary to the original idea.

Analysing Drawings and Sketches in Different Ways

One good drawing, with a couple of colour sketches, could be analysed in many ways. Some can be done in sketch form and others done with greater care. Try to do several of the suggestions related to one drawing, as the comparisons should teach you a good deal:

- A line drawing to find the basic structure. This could be traced.

- A pen and ink, or detailed pencil drawing, to explore line and pattern.

- A charcoal, or pencil, drawing to find the balance of light and dark areas.

- A painting using one warm colour and one cool colour. Translate the colours of your sketch into these.

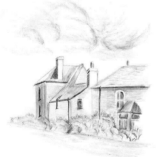 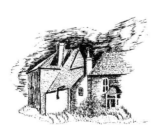

- A painting using primary colours only.

- A painting using the earth colours and a blue.

- A painting using brown and one other colour.

Try different ways of applying the paint — in flat areas of colour, textured in dots, or dabs, or vigorous brush strokes.

85

Try different types of paint.

Change the scale to much larger or much smaller. Enlarge a small area.

It is not likely that you will do this experiment very many times but, even done once, it should demonstrate the wide range of possibilities for interpretation of a subject. So often your familiar way of working becomes a deeply entrenched pattern.

A French purist painter said that 'Art is the demonstration that the ordinary is extraordinary'. You may find, through the experience of these exercises, that your ordinary painting has the capacity to become so much more.

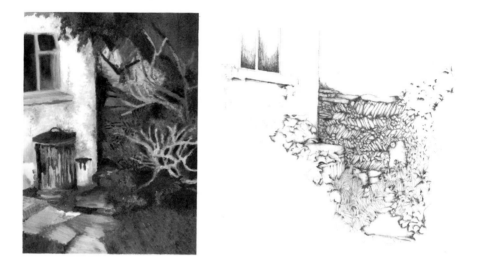

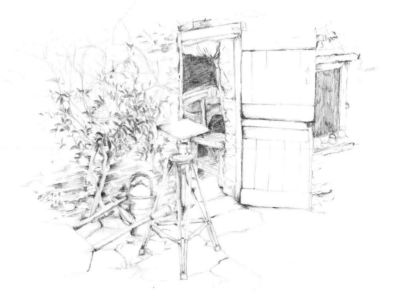

Top Oil on paper (left).
Pencil (right). *Right* Pencil.

Chapter 4
Still-life, Interiors, Flowers

There are a great many advantages in choosing to paint still-life groups and interiors. The subjects do not go away, the light can be controlled, and you can work in warmth and comfort! So many people say they cannot work at home because there is nothing to paint, or that it is impossible to organise in the space available. It is worth trying to overcome any prejudices you may have, as so much can be learned about the craft of painting in this situation. You should remind yourself that what you have to say about what you see, is more important than the subject matter itself.

Materials, Equipment and Organisation

Whether you have a studio, workspace or mobile working area, your materials and equipment should be properly organised, so that you can concentrate on what you are doing. Assess your working practices. If you are naturally methodical you should not find it difficult, but if you are untidy, then try to do something about it. Answer a few questions:

Would it matter if paint or water were spilled on the floor? If so, use newspapers or an old rug.

Are you working in a good light?

Are you working at the right height? Standing gives you the most flexibility but if you prefer to sit does your chair allow freedom of movement?

Do you prefer your board flat, slightly raised or upright, as on an easel?

Can you easily reach your paints, palette, brushes, water or white spirit? If you are right-handed, are they on the right-hand side? (Those items you use most should be nearest to you.)

Is the palette clean when you start, or do you allow layers of old paint to build up so that you cannot see the colours you are mixing?

What are your brushes like? Did you clean them properly last time and can you keep them clean while working? Two containers — one for mixing, one for cleaning — are essential and maybe the one for cleaning should be larger.

Have you plenty of rags?

Working indoors, you will not be limited by what you can carry — you can choose whatever medium suits you best, or take the opportunity to experiment in different mediums or of working on a large scale.

Choosing Your Subject

Once you start to look for a subject you will find the possibilities are endless. Also, it is exciting to find familiar objects and surroundings unfamiliar when being considered as subjects for painting. Still-life groups can be found or set up, flowers need to be arranged and interiors selected.

Selection is a matter of training your eye to see the balance of a composition in shape, main construction lines and colour — it is not easy and you will learn by

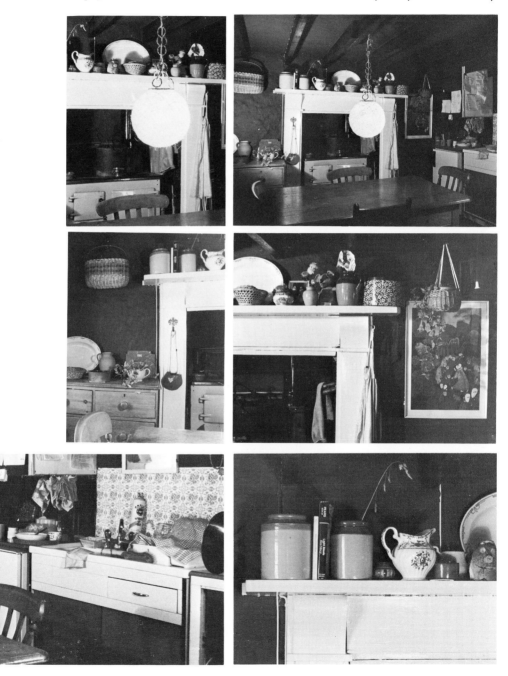

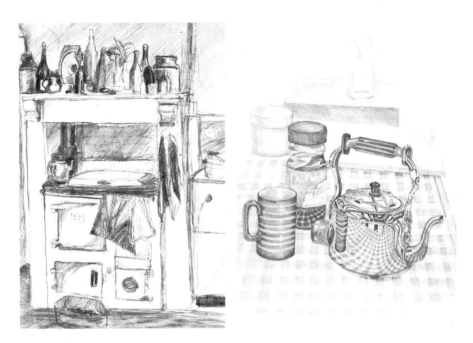

experience. However, a view-finder will help you to concentrate on one area uncluttered by what surrounds it.

You may decide that you would rather 'set up' a still-life group or that you want to paint flowers. Beware of contriving an unnatural situation, which will be difficult to cope with and the results will show it. For instance, fruit and vegetables do not normally belong to the mantelpiece in the sitting room. Perhaps you could paint them without the incongruous surroundings, but how would you cope with the background? Effective lighting may get over the problem but it would be easier to paint them on the kitchen table, or provide a kitchen table-type environment, if you have to work elsewhere.

The more obvious downfall in setting up a still-life group is to try to relate objects which in no way belong together. Do select your group from a natural situation.

Flowers are very difficult to paint but, understandably, many people wish to do so. Be clear in your own mind what it is you want to achieve. Is it a botanical specimen under which you can write 'Rose'? Is it a vase of daffodils? Is it the pot of garden flowers and foliage on the kitchen window-sill? The latter is less likely to cause you problems with backgound. You can relate it naturally in your painting and not feel you have to paint each flower and leaf.

Method of Working

Having decided where you will paint, set up your equipment and materials.

Check with the view-finder the balance of your composition.

Do a quick sketch of that composition and use card strips around it, moving them in or out if necessary to achieve the right balance. At this stage you could decide to do only a small section of the whole.

90

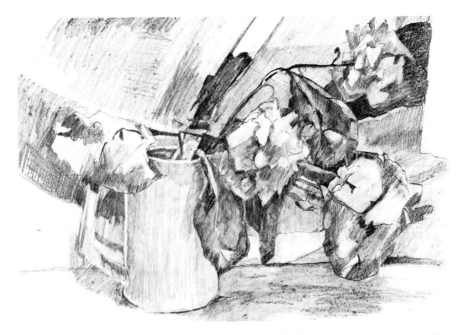

Make sure your painting board or paper is of the same proportion as the sketch. This sounds obvious but you would be surprised how many good square sketches are squeezed into oblong paintings.

Decide which colours you will use. This should be as few as possible, and try not to add to your selection later.

Try to work directly in paint. Use it thinly and work as quickly as possible so that you can assess the balance of your composition at an early stage.

Now the drawing should be considered. Work from a central area and relate object to object and objects to the background, correcting with paint where necessary.

Every so often assess your painting. The general composition has been established, but do you need to change the emphasis anywhere? Is the drawing reasonable? Have you thought about light and shade? Have you concentrated too much on the main objects and left the background? Is the background painted in a different style and if so, is this right? Have you thought about the way you are applying the paint?

If you are using oils and your painting is becoming muddy, maybe you should leave it for a while.

You will have finished when you feel you have no more to say in that painting. However, knowing when to stop can be difficult to decide, and working too long can produce a laboured result, yet the problems which are evident to you must be resolved. Experience and, often, another opinion will help.

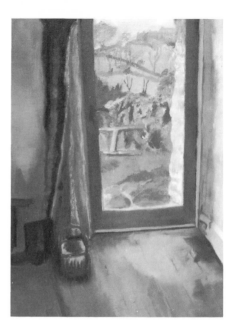

Suggestions for Further Working

Ideas may seem to be limited when you have to rely on the resources of your own home but if you add to the subject matter different ways of looking at it and different ways of working, the possibilities are inexhaustible:

INTERIORS — general views: a corner of the kitchen, sitting room, bathroom, bedroom; looking upstairs, looking downstairs; looking from one room into another; looking through doorways; the area around the window and what you can see outside as well.

NATURAL STILL-LIFE GROUPS Boots and shoes left by the door; books and coffee cups on a table; objects on a window sill; log basket and fire-irons by the fireplace, objects on a bed-side table, dressing table, bathroom table; open cupboards, shelves; the breakfast table after the meal, cooking utensils; preparations for cooking; dishes on the draining board; cleaning equipment.

ARRANGED STILL-LIFE GROUPS Some of the above suggestions could be regrouped elsewhere to be more specific studies such as boots and shoes, pots and pans, bottles, glasses, jug and cups, fruit and vegetables, clothes on a chair, iron and ironing board, musical instruments, fish or other food on a plate.

DETAILED STUDIES You could select single objects from the above suggestions and take your composition from part of that object, such as a section through a piece of fruit or a vegetable; reflections in a kettle, or glass; a shell, fossil, piece of rock or mineral; an iron; food-mixer; the inside of a plug, watch or radio.

FLOWERS A pot of flowers on a table or window-sill; different sorts of flowers; foliage in winter, detailed studies of flowers.

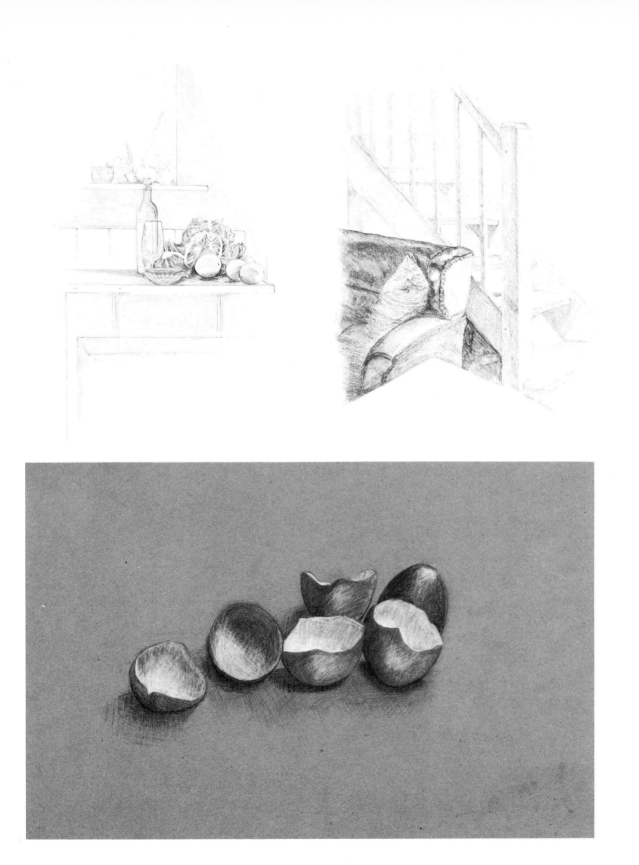

Different Ways of Looking at the Subject

A fresh stimulus to painting everyday objects and situations can be provided by looking at them in different ways.

You can change the lighting to increase the effect of light and shadows. This can be useful if no suitable background is available. Shadows of the objects can be thrown onto a light background and automatically give a relationship between the two.

You can change your view-point from the conventional one — by putting the group on the floor and looking down on the objects, or by positioning them well above you. The objects on a piece of glass placed above you would make an exciting composition.

You can place one object from the group very close to you so that its relationship to the others beyond seems to be distorted. You can divide the space by looking through chair legs or banister rails.

You can look at objects in reflective surfaces, such as a kettle, or a curved mirror, or use foil as a background or base. Aluminium foil can provide a useful background to still-life groups, flowers and detailed studies. The distorted reflection will relate to the objects in colour and shape to give a new dimension to your painting.

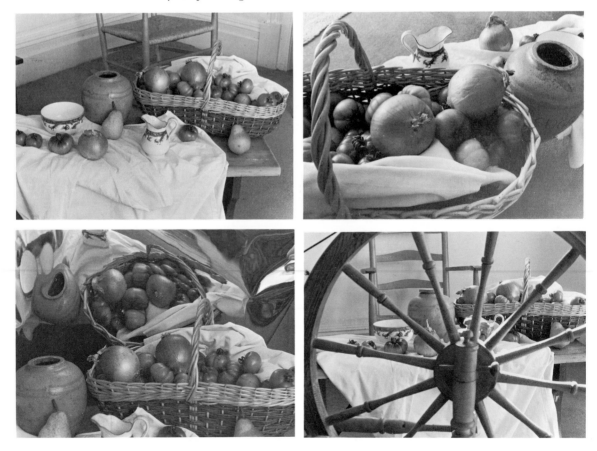

Different Ways of Working

A new incentive to your work could be given by changes in your method of working, or in the materials you use:

Concentrate on drawing, using different drawing materials and methods.

Experiment with a new painting medium.

Change the scale of your work.

Use different colour combinations.

Experiment with different styles of painting.

Use the same subject in different ways.

Look at the work of well-known painters of still-life groups, interiors and flowers. Set up a situation similar to that in one of their paintings and you will learn quite a lot about composing a still-life group, but the painting will be entirely your own and not a copy.

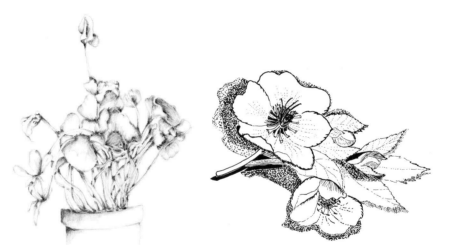

Page 92 Pencil (centre). Oil on paper (right).

Page 93 Top Pencil. *Below* Conté.

This page Top Pencil (left). Pen (right). *Below* Water-colour.

Page 94 Below (left) The image is distorted in a mirror-coated plastic sheet.

Page 96 Poster painting.

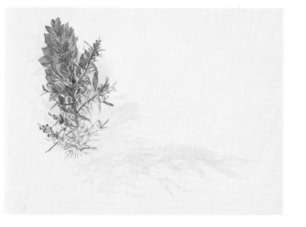

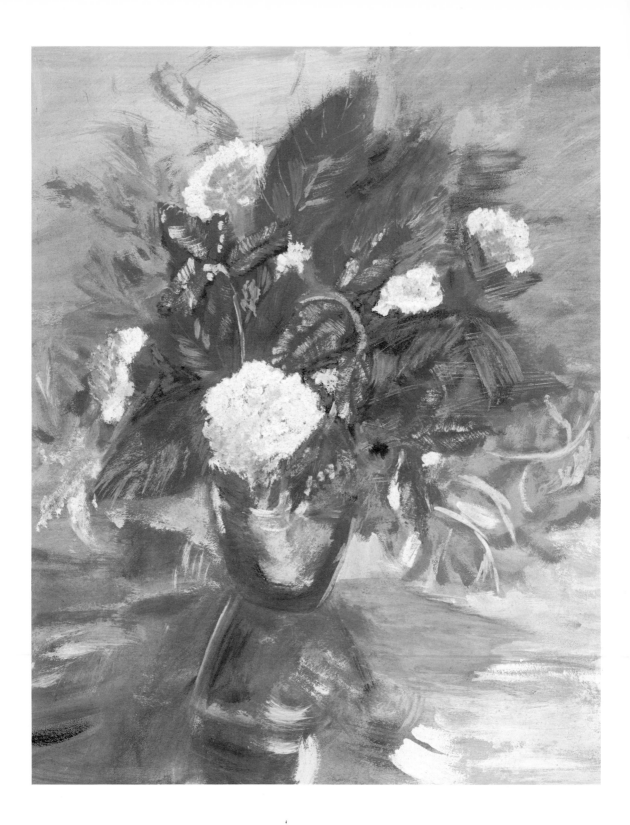

Chapter 5
Figure
Composition

Human figures have been the main subjects of paintings ever since painting began. The development over the ages of the artists' conception of the human figure makes a fascinating study. You could look at religious paintings, portraits, family groups, figures in landscape, figures in interiors. Some paintings tell you about events, and others a lot more about people. Whatever the reason for doing it, whatever the method of painting, the human figure as a subject for painting provides not only an insight into human nature, but also a means of exploring the problems of painting itself.

Unless you have the opportunity to go to Life Drawing classes or can find someone who will sit for you for long enough, portraits and detailed figure paintings are not a practical proposition. However, figures in a landscape, in an interior, in a working situation can provide a fresh element in your painting as part of the composition but not as the sole reason for doing it. You could, of course, try a self-portrait for at least you will have the co-operation of the subject, and it is a good way to build up your confidence even if you do not like the results. Lack of confidence is, probably, the biggest barrier to attempting figure painting. A still-life where the pots are not quite the right shape does not offend in the same way that misinterpreting a friend's face does. So, the suggestions which follow on what to attempt and how to go about it are to help you take courage and explore this area of painting.

Materials, Equipment and Organisation

The professional studio portrait painter is lucky enough to have the sitter coming to the studio where materials, equipment and lighting have been well-organised. You will most probably have to go to your subject and, as with landscape painting, you and your equipment need to be mobile. What you will take depends upon the situation but this is not a time for experimenting in materials that are unfamiliar as you will find there are problems enough without adding to them inexperience in the medium. There are several situations that may arise and you need to be prepared for them.

FIGURES IN LANDSCAPE This situation will occur naturally as you are painting outdoors and the introduction of figures into your painting is likely to be an

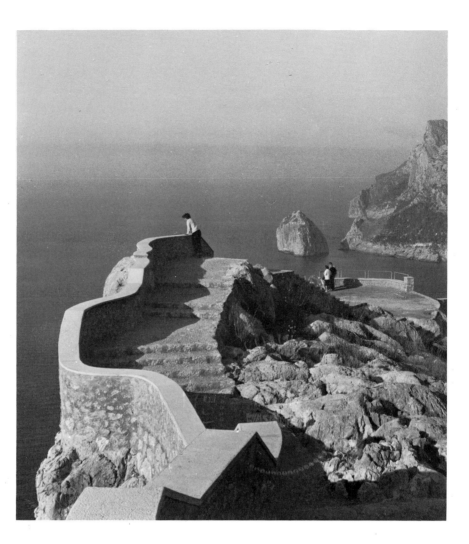

North coast of Majorca.

intuitive response. The materials you have available will suffice.

SKETCHING A sketch pad and pencil or other drawing medium can easily be carried wherever you go. Quick drawings done unobtrusively can be a useful reference later, and detailed studies will help build up your confidence.

FIGURE PAINTING INDOORS You may choose to do a painting of an elderly neighbour in her kitchen, in which case you need to be as well prepared as for working outdoors, if not better, as the person concerned needs to be considered. It may be advisable to make one visit with sketch-pad and pencil to do preliminary drawings. At home you can sort out the composition, decide on the shape of board or paper and the paints you will use, so that when you arrive to do your painting you can start without a fuss. You should remember to take an easel, or organise something to support your painting and some sort of cover for the floor.

SELF-PORTRAIT Looking at yourself in one mirror will present many problems, including that of the picture being back to front. It is difficult to arrange your materials and equipment so that you can see yourself and your drawing or painting at the same time. If you arrange two mirrors at an angle to each other so that one mirror gives the reflection of the other, not only will your picture be the right way round but also you will be able to work more easily.

Choosing Your Subject

Figures in a landscape, or as part of an interior, make a considerable impact and you should think carefully whether they contribute to the painting or even destroy it. You should consider the scale of the figures, their position or grouping in your painting and ensure that the way you paint them, and the colours you use, harmonise with the rest of the picture. Your early attempts at figure painting, where the person is the main subject of the painting, should be thought out carefully if you are not going to be deterred from ever trying again. It is no good trying to make a reasonable painting from inadequate sketches, or working from a subject who is moving around. Organise a situation that is practical, such as a friend or relation sitting by the fire, at a table, in the garden — in a position where they are comfortable and will stay, allowing for short rests, for several hours. If you feel hurried you will not make a good job. When you have gained the confidence by doing several figure paintings, then you can try groups of figures in different situations, using different methods of working.

Method of Working

Set up your easel, materials and equipment in a good light and where you can see your subject without peering around your board.

Use your view-finder to consider the balance of your composition. How much of the background will you include? Should you move or remove anything in the background? Have you chosen the best angle to work from?

Do a quick pencil sketch of the composition.

Use paper or card strips around the sketch and by moving them in or out where necessary decide on the best balance of figure to background. Do not exclude the background as you will find it helps considerably to get the right proportions with the figure.

Decide which colours you will use. The fewer the better and try not to add to them later.

Try to work directly in paint, using it thinly to get down the main areas of colour so that you can consider the composition as a whole from an early stage. If you find this difficult and feel the need to draw first, then use charcoal or chalk rather than pencil. Hard pencil lines seem so uncompromising and usually lead to the painting being just a filled-in drawing.

At this stage you will need to consider the drawing. Do not be afraid to alter obvious mistakes but details of hands and facial features can be left until later.

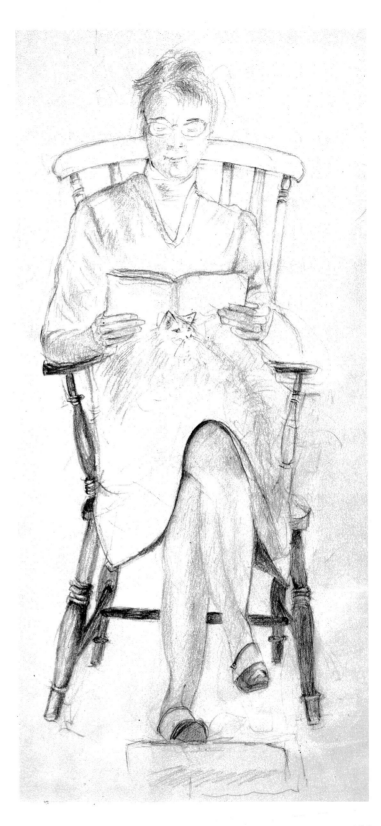

Pencil drawing.

Proportions, however, do matter and should be checked. Use your pencil or paintbrush at arm's length to assess the relative proportion of head to body and to legs and check that your painting agrees with these proportions. Also, it will help the drawing if you work from a central area, where the arm rests on the chair arm for instance, and relate small areas to each other and to the background.

Assess your painting every so often. Consider the composition, the colour, the areas of light shade, the drawing, the way you are applying the paint.

Remember that your model will need a rest from time to time!

Faces, hands, legs and feet seem to cause the greatest difficulties but you should remember that the painting is more than the sum total of those features. It may help to do a few separate drawings to understand their structure. You should be careful that because you find difficulties, you do not alter your style of painting. Remember that the basic principle of drawing is to start from a central area and work outwards. Work from an eye to the nose, to the other eye, to the mouth and so on rather than defining the outline of the head and filling in later.

Your sitter probably will not be prepared to give the amount of time that you are, so take advantage of the periods when he or she is available and at other times consider the related areas and the painting as a whole. When all is said and done, your picture is a figure composition and not a portrait for posterity.

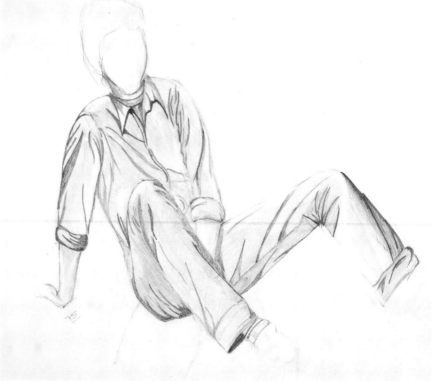

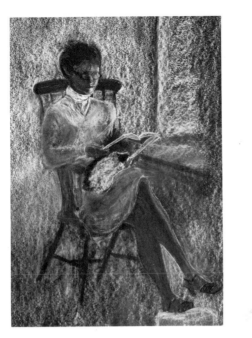

Drawings: in pencil on *opposite page* and *right*. Pastel drawing *left*.

Suggestions for Further Working

You will have realised by now that paintings with people do not necessarily have to be recognisable portraits and that the scope for further paintings is very wide. You need only study the work of one or two well-known figure painters to confirm this and to give you ideas how you might develop your own work.

Basically, you have three ways of working:
- Drawing or painting from a model in a set situation.
- Self portrait.
- Sketches and studies which can be developed into paintings.

The first has been dealt with in detail and applies to the second also, once you have organised the mirrors. The third way needs considering as it will provide the most practical and extensive way of developing your work in figure composition.

Working from Sketches

It is essential to acquire the habit of using a sketch book. Not only will it improve your drawing but it is a means of recording ideas for future paintings. These are the ideas which do not come out of your head but are specific situations which make an impact on you and need to be recorded at the time — a girl standing by the window, two old men on a park bench, visitors to a gallery, a shopkeeper.

In order to develop these sketches, your method of working will be different from that you use for still-life groups or even landscape paintings. The sketches that record the first impression will not be adequate for a painting but the idea, the relationship of the figure to the situation, the colour, the effects of light can be developed into a painting and further sketches and studies will have to be done.

103

One of the dangers of this way of working is that you can lose the spontaneity of the first sketch but being aware that this can happen, you should overcome it and find a way of working that gives you an endless source of subject matter.

It may be possible to recreate the situation or part of it at home which would help in giving you some direct painting. You may have to return to the situation and do some more drawing or painting there. You may need someone to model for you to get a more detailed picture.

Top Pencil. *Below* Poster painting.

Opposite page Pencil.

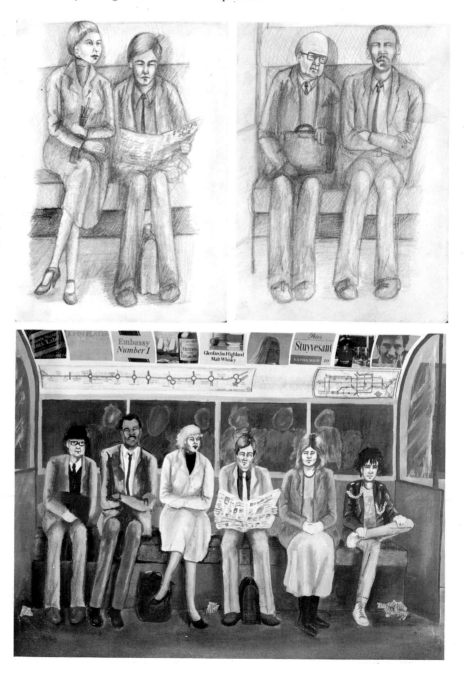

It may be necessary to supplement your first sketch with further studies but if the original idea is strong enough it will maintain its stimulus as you work and your finished painting will convey the excitement you felt originally.

Subject Ideas

Figures in landscape: as vague impressions but as important as punctuation marks; on the beach; in the street; through the trees; on a hill; on a bridge; in a doorway.

Figures as part of the composition: where the figure and the environment are equally important; situations at home such as the family at supper; doing the washing; sitting by the fire; in the bedroom; in the garden; in the garage. Situations outside, such as in the park; outside the shop; inside the shop; building workers and other work situations; in the pub; at an hotel or cafe; in a garage; in a train; on the beach; at a gallery or theatre; at the races.

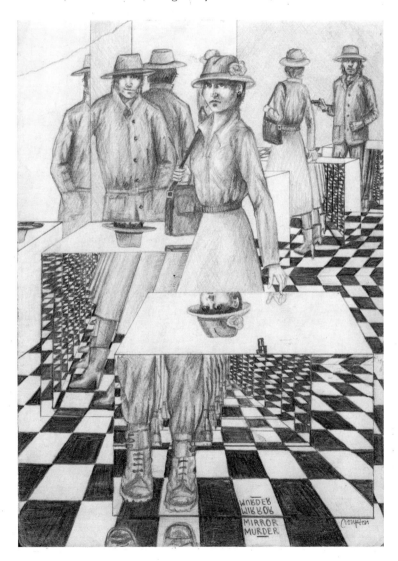

Page 106 Top Oils. *Below* Watercolour (left), ball-point drawing (right).

Page 107 Top Pencil (left), gouache (right). *Below* Oil on paper.

105

One figure as the main subject of the composition, not necessarily a portrait but where the character and attitude of the subject are important. Most of the suggestions above could be concentrated single figure studies.

Portraits and self-portraits in which the character and personality of the subject are as important as the general appearance and the situation.

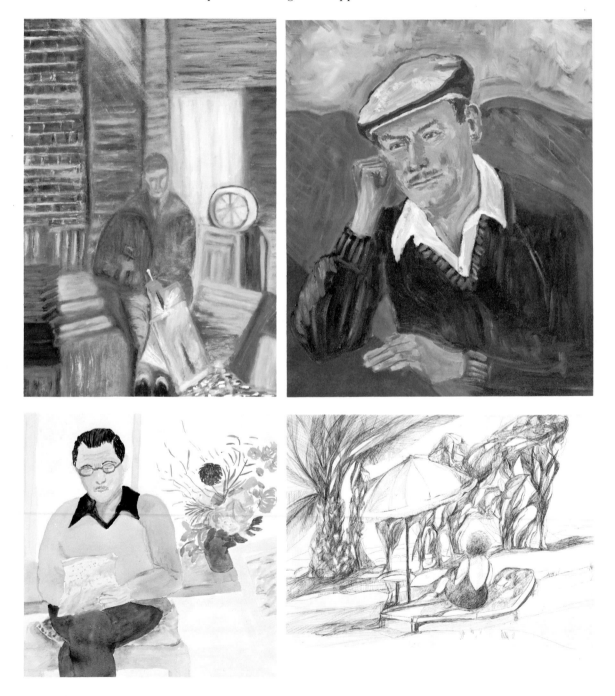

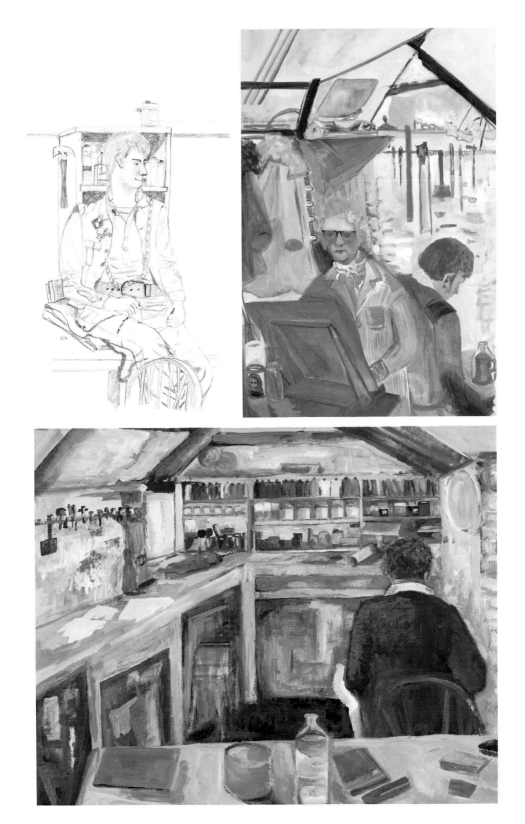

Chapter 6
Understanding

You can use words without understanding grammar, you can sing without understanding musical notation, and you can paint pictures without understanding the language of painting. However, there comes a time when lack of understanding precludes progress. Texture, pattern, line, tone, colour, shape and composition are words that artists use, sometimes carelessly, to describe intentions in their work. But, how much do you know? Pattern is more than a design on wallpaper, colours have a tonal value, and shapes in a composition are affected by all these factors. The discussion and suggestions in this chapter are to help you understand what you think you know, and if you do to reassess the language of painting.

Texture

Paints have their own textural qualities — one talks of the 'feel' of paint as an enjoyable experience. The things you see and want to paint have their own textural qualities too, and light enhances and changes their appearance. You will have discovered quite a lot about the texture of paint and you can observe and feel the roughness and smoothness of the things you see. As a painter, you should be able to record these textures.

You will need:
- Plenty of paper
- Your painting materials

When you started, you experimented with different ways of using the paint. You may need to repeat these exercises, or at least re-read *page 50* to remind yourself of the range of possibilities. Do not worry about the colours you use for this exercise as colour can be deceptive and you will be looking at texture. Black and white would do. Also, do not be deceived by pattern, for by painting every leaf on a tree, you could apply the paint as if you were painting a wall. It is not that this is wrong, but you should be looking for an equivalent texture.

Look around you where you are working and try to make painted surfaces look (not necessarily feel) like the surface of what you see. For example:

- Your clothes — show the difference between wool, cotton and leather.
- Your skin, your hair.
- The walls, the floor, surfaces of furniture.
- Lawns, long grass, bushes, trees, flowers, sky, sea.
- Glass, metal, wood.

110

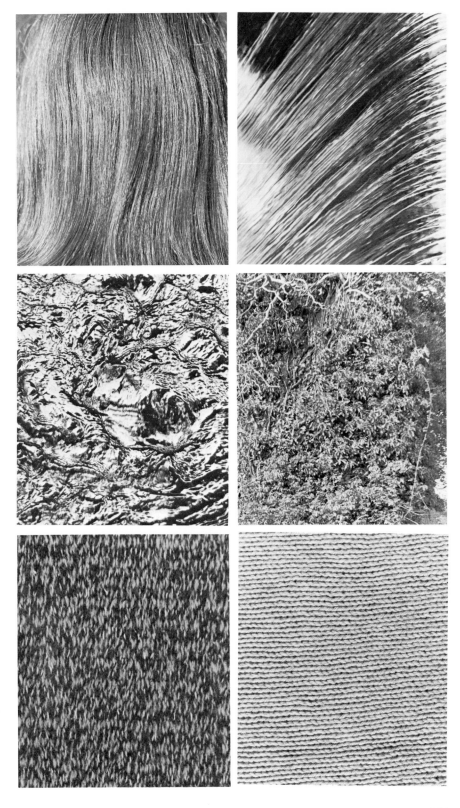

Top Back of a woman's head (left). Water in a weir (right).
Centre A fast-flowing river (left). A creeper on a ruined cottage (right).
Right A woven texture (left). A knitted woollen jersey (right).

111

Work from what you see and not from memory and try to record the surface texture and not the shape.

Set up a still-life group using objects of a similar colour but which have a wide variety of textures. Restrict your palette so that you can paint your pictures concentrating on the textural equivalents you can achieve. If you are excited by the surface quality of pictures you may want to experiment in other ways.

You could experiment with different paints. If using acrylic, sand, powders and such like can be added to the paint.

Try painting on different surfaces. With hardboard you could alter the surface at the priming stage, using a PVA medium with sand or powder, or glue different materials such as old sheets, butter muslin, hessian or tissue paper to the board.

On paper you could use thin paint or ink sprayed onto the surface. A crude but effective form of this method is to splatter paint from an old toothbrush. Aerosol paints could be used but be careful where you work not only because of the mess but also because of the dangers of working with aerosol sprays. An air brush is sophisticated and effective but an expensive piece of equipment. By using cut-out shapes to mask certain areas, you could produce an interesting picture. Some of the suggestions in the section on shape may help you.

Candle wax can be used as a resist to paint. You can draw with it, dribble it on when hot in methods similar to working in batik.

Plate 9 Portraits and self-portraits.

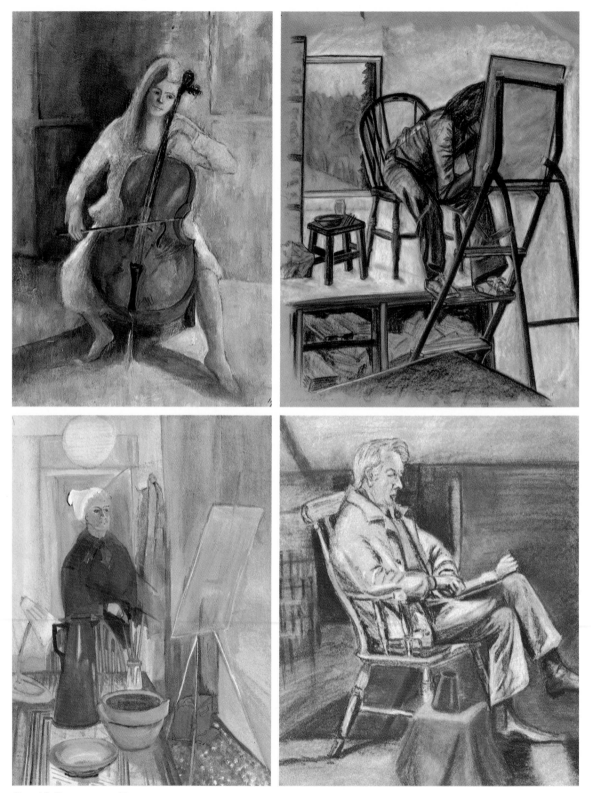

Plate 10 Figure compositions.

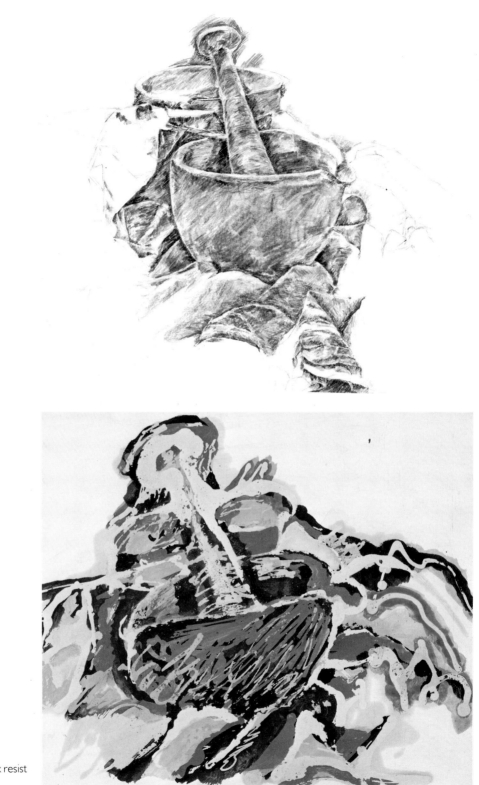

Top Pencil. *Right* Wax resist and poster paint.

Collage.

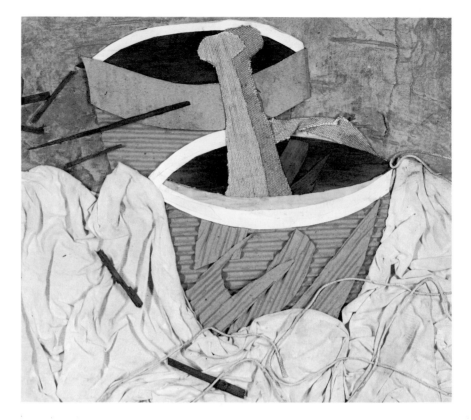

You could combine the use of collage with your painting. Pieces of material, different papers or wood could be stuck to the surface in certain areas, then painted over or left as they are, depending on the effects you want to achieve.

Some painting and drawing materials will mix. You could obtain interesting results by combining pastels with gouache. Acrylic paint can be mixed with almost anything except oil, although it may underlie oil paint. Use any other combination you can think of. Care should be taken if you want the results to be permanent.

Look at the work of other painters. Textural equivalents can be studied from books. How do different painters treat hair, skin, trees or grass? The surface quality of pictures will have to be observed from the real thing.

Pattern

Pattern is the repetition of shapes which are the same, or similar. You can see patterns all around you — in natural forms and man-made structures, as an integral part of the materials used, or as decorative designs on the surfaces of objects. You need to be aware of the many sorts of patterns that you see and to think about the ways in which you use pattern in your painting and drawing. You may be stimulated to work by recognising a pattern of shapes in the subject matter, or in working on a painting, a pattern may become obvious and you want to emphasise it, or it may be that you enjoy for their own sake the decorative patterns that can be produced by the materials and colours you use.

114

You will need:
- Plenty of paper, including tracing paper
- Drawing materials
- Painting materials
- Scissors and glue

Consider the function of pattern in four ways:

1 To provide the structure of a natural or man-made form by using similar shapes to make up the whole, as a series of arches make a bridge, as timbers make the structure of a roof, a chair or a staircase, and as the pattern of veins make a leaf, branches make a tree, as a spiral cell construction makes a shell.

Series of arches making up the leaning tower of Pisa.

2 The grouping of elements, whether natural or man-made, to form a surface pattern, such as pebbles on the beach, bricks making up a wall, leaves on a tree or plant, books on a shelf, tiles on the floor.

Surface pattern — marble floor of S. Giorgio Maggiore, Venice.

3 The repetition of shapes, not necessarily essential to the function, as a means of providing order and unity. Some are not planned but can be recognised as patterns or shapes in a certain situation such as rows of houses, house-plants on the kitchen window-sill, milk bottles on the doorstep, people in a crowd, paint pots on a shelf and fruit in a bowl.

Wheels and their reflections.

4 To provide the superficial decoration of the surface of an object but not essential to its function. Good patterns relate to the object and enhance it, so try to assess what is good and why. Look at patterns used as decoration on things such as curtains, wallpaper, china and pottery, packages, furniture, buildings — old and new.

Fresco in the Civic Palace, Sienna, Italy. *Below* Drawings in pencil.

Do two or three drawings in each of these areas, working from what you can see around you. Try to understand the different functions of pattern. Consider what happens to certain patterns in changes of light, or changes of view-point. Light on a relief pattern will change the shapes according to the angle of the light, and the pattern of tiles on the floor will look different seen in perspective compared with an aerial view. Select two or three of your drawings and do the same subject with a change of light or view-point.

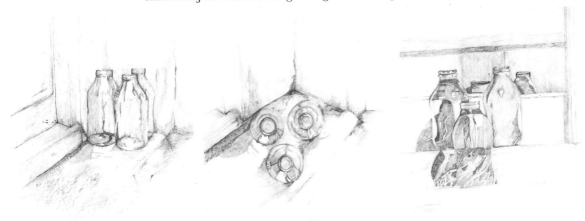

117

Use some of the drawings as a starting point to make patterns which are more obvious, or exaggerated and probably more abstract.

You could try the following:
Working in line only.
Working from a tone drawing. Make the middle greys to black a solid black, and the middle greys to white make the white of the paper.
Changing the scale of the shapes used — make them much bigger or smaller.
Try dividing the pattern of shapes still further by making other patterns within the shapes.

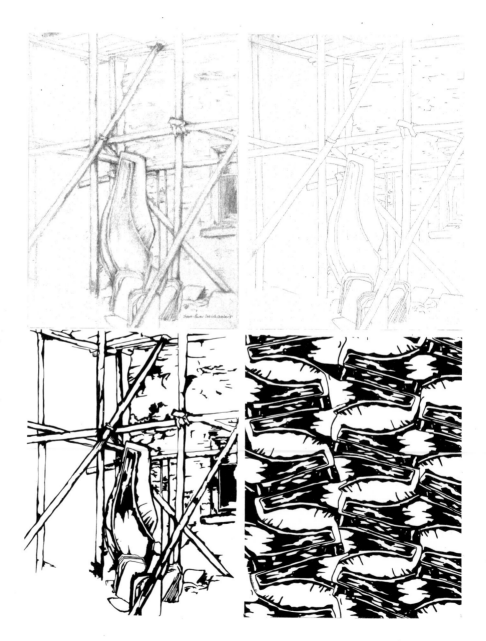

Drawings. *Top* Pencil.
Below Gouache.

118

Cut out one shape several times and arrange them in different ways, first as regular patterns and then irregular patterns.

Experiment with the use of colour in flat areas, or in textured areas.

Design patterns for certain objects or surfaces such as a box, a tray, a teacloth, wall-paper, and so on.

Look at some of the paintings and drawings you have done recently. Do you instinctively make patterns from the things you see? Some people will make patterns out of anything and include patterned or decorative surfaces wherever possible. Choose a fairly small painting or drawing in which a repetition of similar shapes is evident. Make a tracing of it using line only. You could then work from the tracing in some of the ways suggested before.

Look, also, at the work of painters who have a strong sense of pattern such as the Primitive painters, and the Renaissance painters of which Uccello is a specially good example. You should also look at the work of Bruegel, Bosch, the Pre-Raphaelites, and the Cubist and Fauvist painters, particularly Matisse. Pattern used in the decorative sense may be superficial but delightful. An awareness of the pattern and order of shapes and structures can add another more satisfying dimension to your work.

Line

The use of line is the simplest way to draw and yet the most difficult to do well. It is necessary to examine closely the sort of lines you use to express what you see, otherwise familiarity and constant use of line may develop into a personal cliché which is excused as being 'my way of drawing'. In fact, you have really stopped looking because you have ready-made answers to certain situations. It is easy to do an outline but to express the solidity of an object needs a strength, weight and sensitivity of line that is difficult to achieve.

You will need:
● Plenty of paper, including tracing paper
● Drawing materials, such as pencils, charcoal, chalks, pens
● Paint (black will do) and several brushes

The exercises given in the drawing section (*page 42*) should be repeated with as many different drawing tools, including brushes and paint, as you can provide. You will be able to make comparisons between the different qualities of line which are produced by each medium if you take each instruction separately and do it in all mediums before going on to the next. Spend a little more time experimenting with using the brush — different brushes make different qualities of line. To draw with a brush like the Chinese takes a lot of practice but the lines produced by varying the pressure on a brush held upright, are very satisfying.

119

Try to do a drawing in this way — it will help you to concentrate on the subject, although the results may be screwed up and thrown in the bin! Choose something to draw from what you can see around you. Use a fairly large piece of

Different lines produced with pencil, pen, charcoal and paint.

120

paper and pencil. Follow the contours of the subject with your pencil on the paper but do not look at what you are drawing. It takes a good deal of concentration and occasionally you may have to glance at your drawing to begin a new contour. Try this exercise several times, each with a different medium, but do not spend very long on each.

Do a drawing in pencil of part of a building, a landscape, or a still-life. You could use one you have already done and use the tracing paper on top to do several more drawings in different ways, using each of the drawing tools in turn.

Do a continuous line drawing, trying not to lift the pencil from the paper, except when necessary to start a new contour. Vary the weight and thickness of the line to show light and dark.

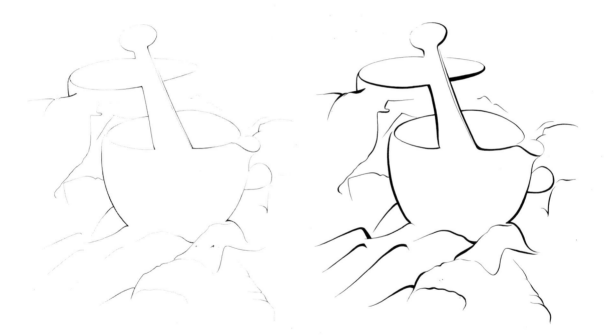

The different mediums will produce different results and you may discover that a change of medium will produce more satisfactory drawing. However, pure line drawing may not suit your style of working, in which case the exercise related to tone may be more helpful.

Look at the drawings of artists such as Leonardo da Vinci, Rembrandt, Turner, Degas, Picasso and Hockney. You could try their style of drawing in one of your own drawings, but remember that it is an exercise to understand another way of working and not a formula for your drawing in the future.

Line drawings. *Left* Pencil. *Right* Gouache.

Tone

It is easier to understand tone in terms of black, greys and white. However, it is a coloured world that is interpreted by those means and all colours have a tonal value. The relationship of colour to tone is dealt with in the section on colour, but to understand this you need to know the meaning of tone itself. Tone value is the range from light to dark seen in any object. You will see this more easily if you half close your eyes to reduce the effect of colour, or imagine what would be the result in a black and white photograph. The following exercises will help you to become more aware of light and dark, and the ways of representing tone.

You will need:
- Plenty of white paper
- Range of pencils — B, 2B and 4B minimum
- Pen — black fibre tip will do
- Black paint or ink, water and fine brush
- Charcoal
- Rubber

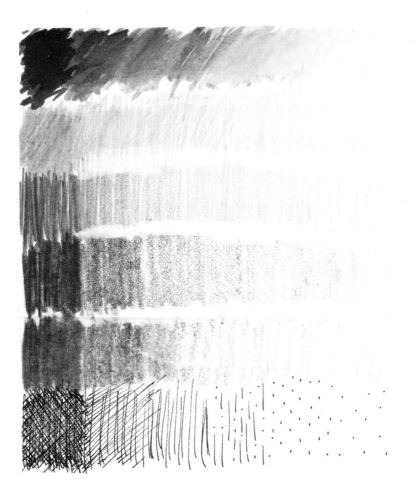

Experiments in tone: paint, B, 2B and 4B pencils, charcoal and pen.

122

- Newspaper and black and white paper
- Scissors and glue

To find the range of light to dark in different mediums:
Start with full strength black ink, or paint, on your brush and make a small area, gradually reducing the strength, recording each stage until you finish with a clear wash.

Work with charcoal in a similar way. Rubbing it may help.

Do the same with each of your pencils.

Try the same with pen. You will have to use a different technique. Pressing harder may produce thicker lines, but the tone can only be varied by increasing the white spaces between small lines or dots.

The range of tone will vary in each medium. You will notice the limitations of a hard pencil and pen. However, these may be used in a number of ways to produce patterns which are, nevertheless, measurable in tone.

Use the pen to make a small area using dots. Next, try smaller dots, dots closer together, or further apart. Use lines, crossed lines, short dashes, small circles, and so on.

Try the same things with pencil, charcoal and ink, or paint.

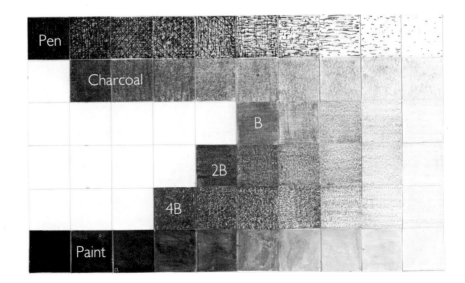

Now compare the range of tones in each medium.

Make a grid of 25mm (1in) squares. Six down by ten across should do. On the top row use black ink, or paint, at full strength in the first square, and gradually reduce the strength across the squares to a tinted wash.

123

Do the same thing in the next row with a 4B pencil, but before you start put the full strength of the pencil on a scrap of paper and see how it compares with the blackest area of ink or paint. Probably, you will have to start three or four places along the row.

Repeat as above with 2B and B pencils, charcoal and pen.

Look at your results from a distance. Reducing the light or half closing your eyes will help to assess whether or not you matched the tones correctly.

Newspaper can give a wide range of tone and you may find it useful to help you think in areas rather than in lines.

Make a range from black to white by tearing out the appropriate pieces from the paper.

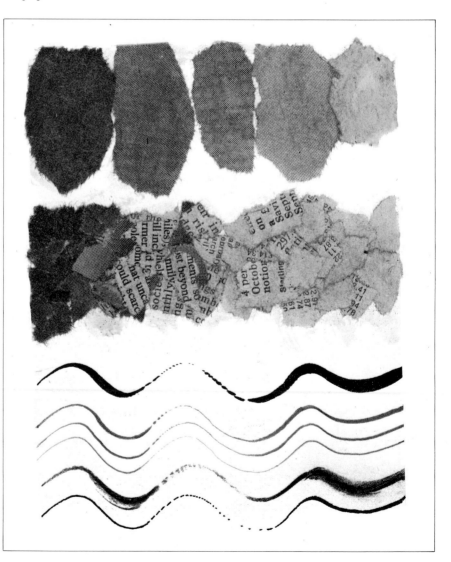

Ranges of tone in newspaper, and in lines of paint, pencil, charcoal and paint.

Make another range using small torn pieces. You should be able to grade the tone more satisfactorily from these.

A line can be varied in weight and width by increasing or reducing the pressure.

Experiment with each medium using lines which are flowing, dotted, done quickly, or deliberately. You will see that a line can vary in tone as much as areas can.

Set up a still-life group using white objects only, such as two or three pots, bottles, cups or plates on a white cloth, with a white wall behind. Fix a light on one side to cast strong shadows. You could do several studies in different ways:

- Charcoal drawing — trying not to use lines.
- Pencil drawing — trying not to use lines.
- Line drawings — varying the weight and thickness of the line.
- Painting — using only black and white paint.
- Pen, ink and wash drawing.
- Newspaper collage.

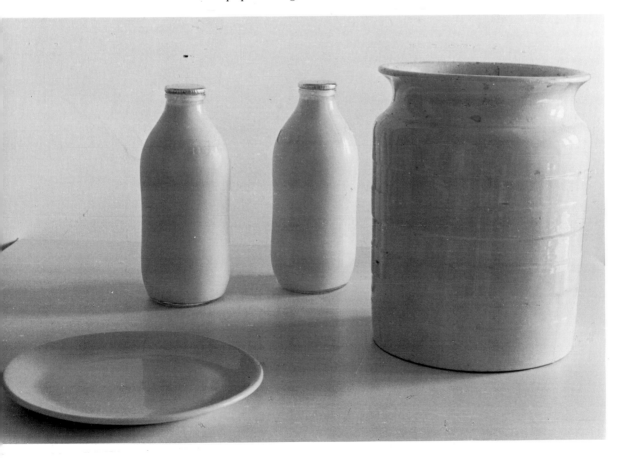

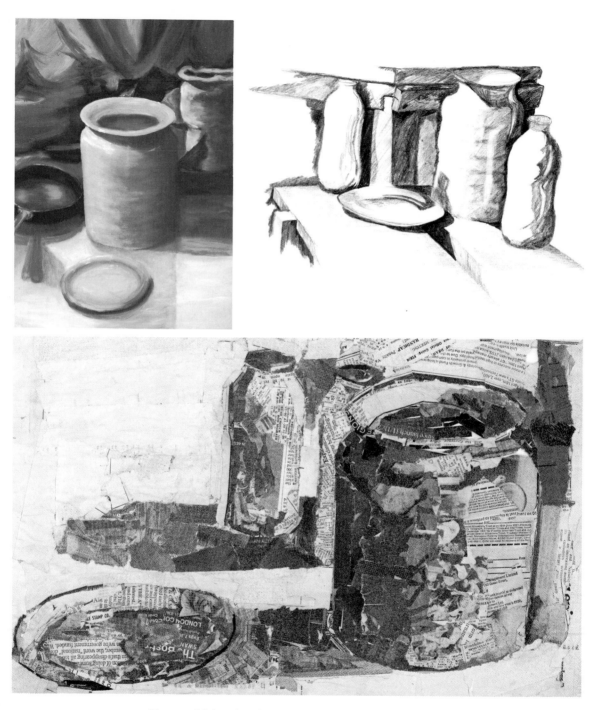

You could develop these studies further by using the methods described before with different subjects. You will find suggestions in the sections on drawing. It is difficult to isolate the study of tone from colour, and line from shape in particular, but these few exercises should have made you realise how wide the range of greys can be.

Colour

These experiments are to help you know and understand more about the colours you use. You should work in the type of paint you normally use, even though the results in poster or gouache will not be as brilliant as those in oil and acrylic. If you are using acrylic or oil, you can mix and apply the paint with a palette knife. If you are using poster or gouache, make sure you wash the brushes thoroughly and frequently.

To do the experiments you will need:
- Plenty of white paper
- Brushes, palette, white spirit or water, pencil, ruler
- Palette knife for oil or acrylic
- Rags
- Paints — Cadmium Red (Brilliant Red)
 Cobalt Blue (Ultramarine, Brilliant Blue)
 Lemon Yellow
 White
 Black
 Any others you may have

Primary, Secondary and Complementary Colours

- Draw a circle, free hand will do, about 50mm (2in) diameter.
- Divide it in the same way as a clock face.
- Put a patch of yellow outside the circle at 12.
- Put a patch of red outside the circle at 4.
- Put a patch of blue outside the circle at 8.

These are the three *primary* colours and they cannot be made by mixing other colours.

- Mix red and yellow and put a patch of orange outside the circle at 2.
- Mix yellow and blue and put a patch of green outside the circle at 10.
- Mix blue and red and put a patch of violet outside the circle at 6.

These are the *secondary* colours. Your results with blue and red may be disappointing. This is because the pigments we use are not pure tints. You will find that crimson mixed with blue makes a better violet.

You could mix *tertiary* colours, e.g. yellow and orange, to make a yellow-orange and so complete your colour circle. These tertiary colours are the hues (shades or tints) of the primary and secondary colours.

Complementary colours lie directly opposite each other so that:
- Red is the complement of green.
- Blue is the complement of orange.
- Yellow is the complement of violet.

Opposite Page Top Oil on paper (left), pencil (right). *Below* Newspaper collage.

Another way to see this is to stare at a patch of red for half a minute or so and then look at white paper — a patch of green light should appear as an illusion.

127

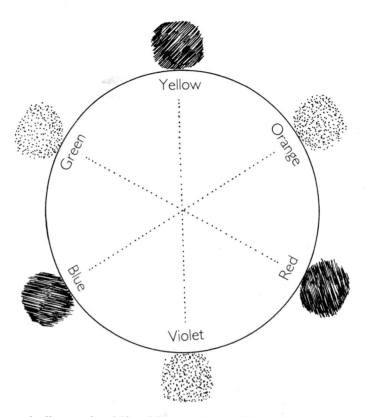

Mixing Colours

Theoretically you should be able to produce all the colours you need from the three primary colours. This does not work in practice, as no doubt you have found out. However, a small range of paints can produce a great variety of colours. You need to be systematic in the layout of these exercises and you may find it easier to use a grid. Draw columns about 20mm or ¾ in wide and divide them into 12mm or ½ in sections. A grid of eleven by eleven sections should do for each range of colours.

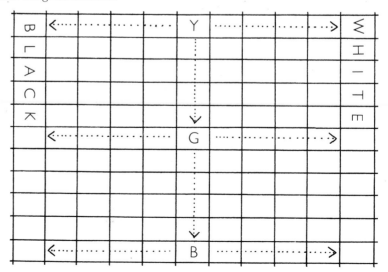

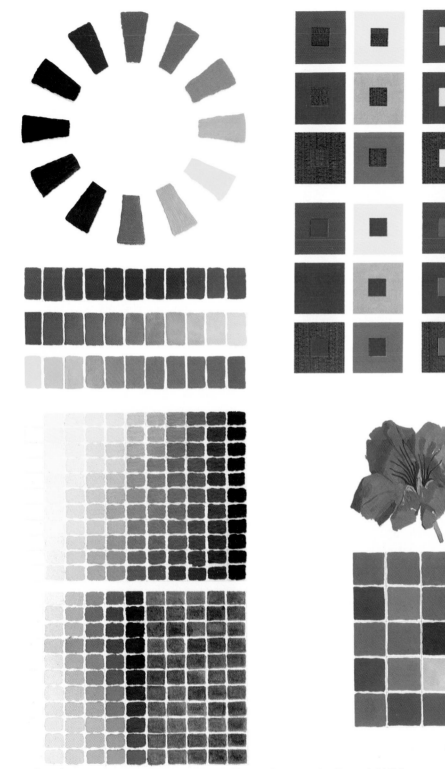

Plate 11 Colour studies: *See pages 127–134. Top left* Colour circle. *Centre left* Mixing two primary colours with black and white. *Below left* Mixing Burnt Sienna and Cerulean with black and white. *Top right* The impact of one colour on another. *Below right* Analysis, in squares, of the colours in a nasturtium flower.

Cadmium Red
Alizarin Crimson
Vermilion
Light Red
Indian Red
Burnt Sienna
Burnt Umber
Vandyke Brown
Raw Umber
Raw Sienna
Yellow Ochre
Naples Yellow
Lemon Yellow
Chrome Yellow
Cadmium Yellow
Cadmium Orange
Chrome Orange
Flake White
Titanium White

Cobalt Blue
Cerulean
Ultramarine
Permanent Blue
Monastral Blue
Prussian Blue
Indigo
Cobalt Violet
Mauve
Magenta
Monastral Green
Viridian
Emerald Green
Chrome Green
Sap Green
Terre Verte
Paynes Grey
Lamp Black

Plate 12 Top left View from a window, from left to right—morning, afternoon, evening. *Below left* Colour chart. *Top right* Analysis of the colour orange, see page 133. *Centre right* Colour related to tone. *Below right* Mixing greens.

● Yellow and blue plus black and white.

Start with yellow and record it in the middle of the top of the grid. Add a touch of blue and record it below the yellow. Gradually, add more and more blue, recording your mixes of green down the centre column until you finish with pure blue at the bottom.

Using these mixes, add white to them, gradually increase the quantity and work to the right. Add black to them and work to the left.

Working in a similar way you can try:

● Yellow and red plus black and white
● Red and blue plus black and white

Brown can be mixed from two complementary colours, and greys can be obtained by adding white. Again, use an eleven by eleven section grid to record the browns and greys obtained by mixing:

● Orange and blue plus black and white
● Yellow and violet plus black and white
● Green and red plus black and white

You could also try such combinations as:

● Burnt Sienna and cerulean, cobalt or ultramarine
● Burnt Sienna and viridian, emerald or sap green
● Raw umber and cerulean or ultramarine
● Raw umber and viridian, emerald or sap green

You may not like some of these tube colours in themselves but will find that they make an exciting range of mixtures. It is necessary to be able to mix colours accurately. At the beginning this means trial and error. You have to decide which colours to use and then the proportions in which to mix them.

Try this exercise:
Work from a cross section of a fruit, vegetable or flower.

Using a pencil lightly, make a grid of 25mm (1in) squares. Your results can be recorded in these so that you concentrate on the mixing and are not worried about drawing the shapes.

Start at the centre, mix the colour and put it down in the centre square.

Record each change of colour, putting it down in the adjacent squares, using as many squares as you need to give the equivalent area.

This exercise could be done with several subjects.

The Impact of Colours

Colours appear to be warm or cool. This is probably the association of orange-red with the warmth of a flame, and blue with cold. However, you can find contradictions. The impact of a colour depends very much on its quantity and what surrounds it.

Put down the warm colours in a group.
Put down the cool colours in a group.

Cool colours appear to recede and contract and warm colours seem to emerge and expand, but it does depend a great deal on the strength of the colour, the size of the shape and the colours that surround the shape.

| Red | Orange | Yellow |
| Green | Blue | Violet |

Put down an area of red (about 37mm or 1 ½ in square) then orange, yellow, green, blue and violet.

Make five more similar groups.

On separate paper make coloured areas about 50mm × 50mm (2in × 2in). These you will cut into 12mm (½ in) squares when they are dry. There will be some left over which you can save for the exercises on tone related to colour.

Stick the red cut-out squares onto one group of six different colours.

Do the same with the orange cut-out squares on the next group of colours, and so on, until you have six sets.

Now, study the results. You will find that the impact of one colour is altered considerably by the colour that surrounds it.

Look at each group and answer these questions:
Which combination do you like best and why?

Which surrounding colour gives the studied colour the greatest impact?

Which makes it appear the lightest or brightest?

Do the studied squares appear to be different sizes and, if so, on which colours and in what way do they alter?

So far these exercises have used primary and secondary colours only. You could increase the range of colours to include another blue, as well as crimson, cadmium yellow and the earth colours. Keep your results for future reference.

Colour Related to Tone and Light

All colours appear to change in different lights. You only have to study a landscape at different times of the day and at different seasons to realise that not only do the colours change but so does the relationship of objects. For painters this can be exciting, and frustrating.

The photographer's house taken in different lights: (l. to r.) morning, afternoon, evening.

131

Choose a scene from one of your windows. Select a vertical strip about 150mm (6in) wide — it may help to mask the adjoining area.

Take a piece of paper and divide it into seven columns, of similar proportions to the strip on the window. Draw lightly, in line, the view seen through the strip on each of your columns — this will allow you to work quickly.

Select your colours and take great care in matching them to those which you see outside. Record each area and try to limit your time to under an hour.

Do the same thing a couple of hours later and try not to be too influenced by your first efforts.

Do a third strip the same way.

Do another three on a day when the weather is very different.

You might find it more interesting to cover each strip after it is completed and only make comparisons when all six are finished.

Do one strip separately using pencil or black and white paint only. This is working in tone.

The tone of a colour is its lightness or darkness and this can be related to a black and white scale. To put it simply, colours are represented in tones when a black and white photograph is taken. It is impossible for pigments to match nature's range of light and dark which is why painters need to develop their understanding of colour in as many ways as possible. Understanding the tone value of colour is very important.

Draw a grid with vertical columns about 25mm (1in) apart — seven columns should do.

Divide these horizontally into eleven sections about 12mm (½ in) apart.

On the left hand side, make a scale of white at the top, going through shades of grey to black at the bottom. This is difficult to do accurately.

Use the 12mm (½in) colour pieces left over from the experiments in impact of colour and try to match them to the white-black scale. Some colours will have the same tonal value.

To test the accuracy of your placings, look from a distance and half close your eyes, or reduce the light in which you see them. If you were successful, the exercise should appear as bands of greys, light at the top and dark at the bottom. The best test is to take a black and white photograph.

You could add further colour mixes.

You could ascertain the position of one colour, e.g. red, and match it throughout the scale, making it lighter in tone by adding white, and darker by adding black. This could be done with several colours, and with two colours that are tonally wide apart, e.g. lemon yellow and prussian blue.

These experiments probably explain why so many amateur landscape paintings look dark and muddy. Green pigment is tonally fairly dark and yet sunshine makes greens very light and bright. You could add white to improve the lightness but only more yellow will increase the brightness and lightness at the same time. You should realise that although the tonal value of a colour is important, some colours still have a greater impact than others. Red and green may be similar in tone but the smallest patch of red surrounded by a large area of green has great significance. Assessing the total value of a colour is difficult and only comes with observation, practice and understanding.

What, for instance, do you know about orange?

Orange is a secondary colour mixed from the two primaries red and yellow.

The orange will be of a different hue depending on the amounts of red and yellow, and which red and yellow it is made from.

Orange paint can be bought as Cadmium Orange, Chrome Orange, and Mars Orange.

The complementary colour of orange is blue.

Orange is a warm colour and tends to emerge.

Orange lies in the upper half of the tonal scale.

You could explain these facts visually with orange and other colours. You could add mixtures with other colours to make browns and greys.

Paint Colours Available
You should make your own colour chart. The ones that are produced for catalogues give a rough guide, but your own should be an accurate reference. It could be an expensive experiment which you might need to share with a few kind friends. Use a palette knife, or put the paint straight from the tube onto

the paper, and rub one end with your finger to see the reduced colour. Record in groups all the colours you have available and name them.

These colour records on strips of card are quite useful to keep in your paint box for reference.

Selecting a Palette

You need a selective eye to choose your painting colours. Very often it can only be an arbitrary selection based on what is available, and a tentative decision as to what is needed, with more added later if the original choice was incomplete.

As a rule, use as few colours as possible as this will develop your ability to mix colours, and give your painting greater harmony.

Suggestions for Further Working

If you are going to paint a landscape, take from your supply all those you think you may need. Look at each in turn and decide whether or not you could manage without it. This will eliminate several. Look at what is left. Could you mix a good range of greens? Do you need red, or would burnt sienna or orange do as well? Now, do the colours you have chosen create the right feeling for the subject you will paint?

Try using two primaries plus one secondary which contains the third primary.

Try one primary and one secondary (mixed or straight from the tube).

Prepare your palette only using colours from the top half of the tonal scale.

Use one warm colour and one cool colour only.

Use two warm colours, or two cool colours only.

Look at your colour experiments for other possible combinations. Your choice should always be a conscious selection.

Other Suggestions

Read about theories of colour.

Study the work of painters who were particularly interested in colour theory, e.g. the Impressionists, Seurat, Cézanne, Paul Klee.

Study the palettes of other painters and try using their combination of colours in your own work.

Develop these experiments into more considered paintings. *See* chapter 7.

In landscape, still-life, interior and figure compositions, set yourself a series of studies with particular reference to colour. Each of these sections in the book has suggestions for working and you could link them by using the same palette for a painting from each section.

These studies and experiments in colour are by no means comprehensive, nor a task to be completed once and then forgotten. This time you may have used oil paints, later you may take up watercolours and find it useful to repeat the experiments. You will discover new facts and your understanding will increase by repetition of once tried methods.

Shape

Objects are identified and remembered by their shape. The symbols used to represent, for example, a man, a bird, a tree or a cat are universally understood. The artist's visual memory is, of course, more sophisticated than this simple sign language, but it is all too easy to resort to symbols when faced with difficulties in drawing. If you cannot draw a three-quarter view of a sitting person from memory, then you say it is difficult to draw. The answer, of course, is to look, and to draw from what you see. A good visual memory can be dangerous if it stops you looking and drawing what you see, as pictures can be concocted from the symbols in your personal visual dictionary. On the other hand, remembered images can have a great impact when used to express a significant experience. The following exercises should help to make you more conscious of the shapes you use, and why you respond to some more than others.

You will need:
- Plenty of white paper, tracing paper, and one sheet of a coloured paper
- Pencils, or charcoal, and a rubber
- Your paints
- Scissors

Draw a few objects from memory, e.g. a table, a face, milk bottle, scissors, a tree, a chimney stack.

Do you take the conventional view so that the object is recognisable?

Do you draw around the outside of the shape and then fill in the details?

How good is your memory when you compare your drawing with the real thing?

Ask a non-painting friend to do the same exercise. The comparison should be interesting and you should feel better!

It is likely that you have used lines and a fair amount of detail to describe the shape, but how good is your account of the shape itself?

Use the coloured paper and scissors and try cutting out the same shapes from memory.

This is more difficult than drawing the objects but the results will make a strong impact as the shapes will be seen as silhouettes. These silhouettes are the shapes of the objects. However, an object may appear to change its shape depending on:
- The angle from which it is seen.
- The way it is drawn: hard or soft edges will change the appearance.
- The colour of the object: this will affect the impact of the shape.
- The light falling on the object: strong light may obliterate the recognisable shape altogether.

135

Cut out the shapes of a few objects as you are looking at them: a table, chair, telephone, teapot, or a tree in the garden.

Select one of the objects and cut out its shape from different angles — straight on, three-quarter view, from above, from below.

You will find that from some angles the object appears to lose its accepted identity, and yet you know that you worked directly from what you could see.

Cut shapes will have hard edges, which may be suitable for some objects but not for all, and this method of exploring shapes is limited.

Work now with a soft pencil, or charcoal. Choose one of the objects indoors so that you can control the light.

Do a straight-forward drawing of that object, using light and shade, and line where necessary.

The next three drawings could be done using tracing paper over the top of the first drawing. Light the object so that one side is bright and the other merges into the shadows.

Draw a continuous line around the outside of the object, including the shadow.

Use areas of shading only, relating object to background.

Clearly define the areas of shading into three tones: light, being the white of the paper, medium and dark.

You will find that there are areas where there is no distinguishing line between parts of the object, and the object and its background. The object appears to have changed its shape because of the light. This is a fact worth remembering when you are working in strong sunlight or have controlled the lighting indoors.

137

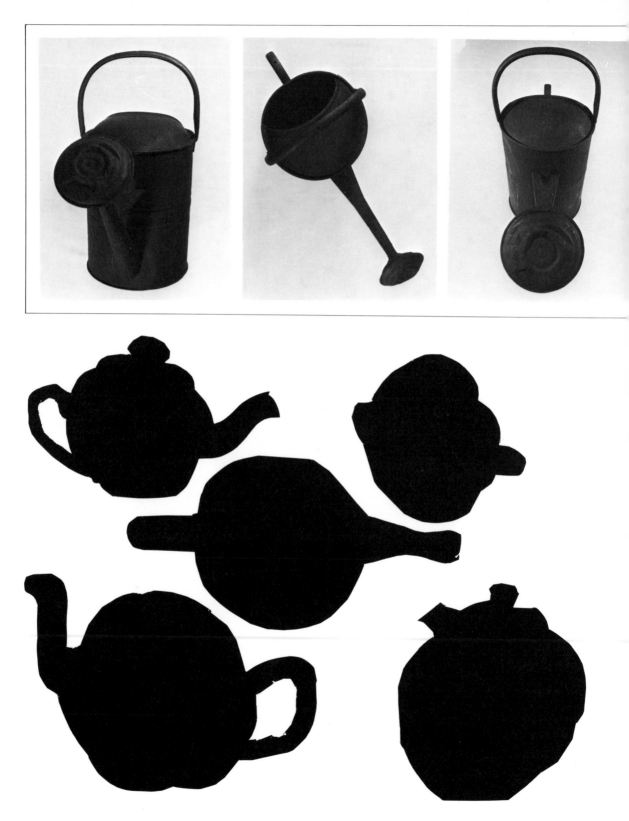

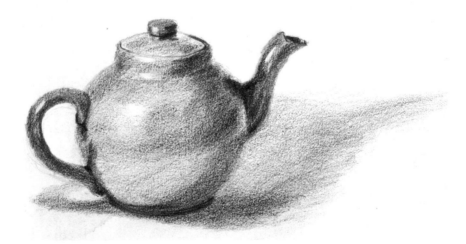

The impact of a shape will be affected by its colour and the colours which surround it.

You can use the same subject as before, change it by adding another object such as a pot on the table, or work from a still-life painting you have completed.

Do a straight-forward painting using the colours you think are right.

Do another painting working in flat areas of colour. Mix one colour only with black and white to give at least six shades, which will be used separately.

Now do a third painting, still in flat areas of colour, using one colour and its complementary colour. You will need to think quite hard about the colours you choose. Green, blue, and purple with their complementaries tend to

Opposite page Paper silhouettes. *Right* Drawing in pencil.

139

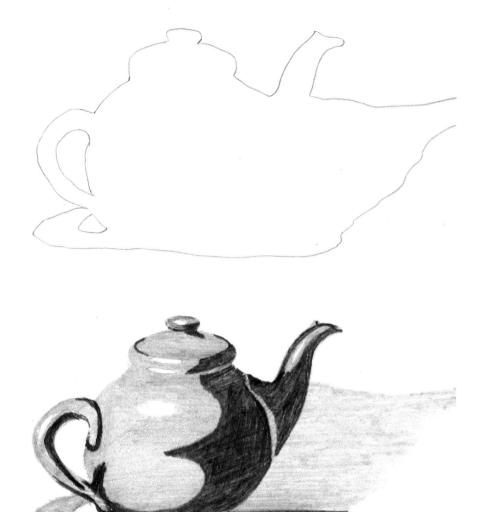

recede, but also bear in mind that red and green have a similar tonal value. Make all the dark areas one colour, and the light areas the other. Remember that the in-between tones will have to be one or the other.

These exercises may help you to understand how some apparently abstract paintings have been achieved. The painter becomes fascinated by the problems of technique and experiments in different ways to understand the problems. The results produce something new and exciting, beyond the accepted representation of facts. But, of course, the facts are different, just as the shapes were different when you cut out the same objects from a number of angles. Try organising these into a composition by overlapping and super-imposing as this may help you to understand how the cubists like Braque and Picasso thought

Gouache paintings.

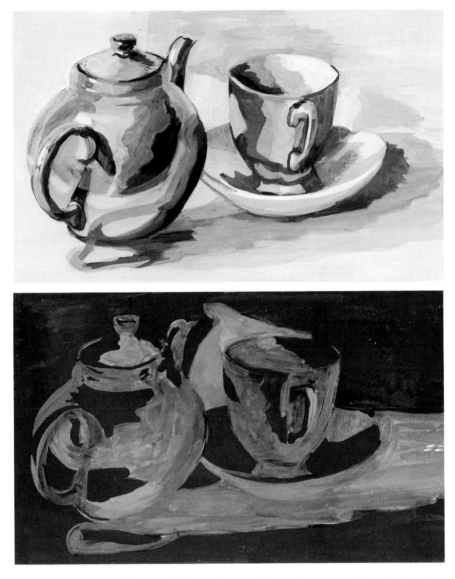

about their work. You should have learned from these exercises the significance of shape in your painting. It is closely related to the composition of the painting where groups of shapes have to be considered in relation to each other.

You could develop these studies further by:

— Doing the same exercises with other subjects.

— Using the cut-outs of one object and organising them into a painting.

— Exploring the possibilities of working in flat areas of colour using complementary colours, graded colours, receding and emerging colours.

— Trying collage — a picture made from paper, material or other cut-outs.

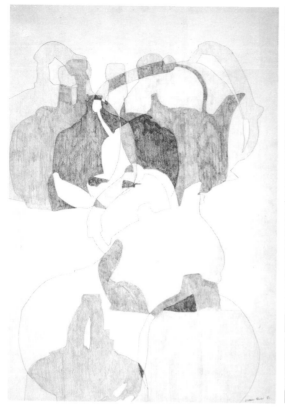

Flat areas of colour make the shape obvious, so try the opposite to collage: painting a shape emerging from its background.

Try distorting a shape — elongate it, make it rounder, make it more angular. Look at a shape in a curved reflective surface such as a spoon, kettle, or a glass. Look at reflections in water or on creased aluminium foil. The same object can appear to have many different shapes.

Paint the same object in as many ways as you can.

Look through a book on painting and find out how differently artists have interpreted one shape, such as a table, jug, or face.

Have you noticed that one sort of shape occurs frequently in your paintings? Many painters are recognised by their use of one shape in particular as they tend to choose subjects or interpret the subject using that shape. Try to analyse which shape or shapes you have an affinity for and why. Is it the images that are recreated by that shape, or is it the shape itself?

Composition

A painting may be composed of lines, tones, colours, shapes, textures and patterns. Its subject matter may be representational or abstract, and its content may be figures, or trees and fields, or buildings, or fruit and pots. The way in which these are organised to form the whole painting is its composition.

Opposite page Pencil (left),
poster paint (right).
Below Oil on paper (left),
pencil (centre and right).

However, the painting as a whole is more important than the sum total of its parts, and the balance of form and colour more important than the strict identification of the subject matter.

How do you know when a painting has a good or a bad composition? Your judgement should not be affected by whether or not you like the subject matter, nor by your intuitive response to the colours used. An inbalance of shapes and colours, poor techniques and bad drawing are obvious, but sometimes a good painting can have all these faults and a bad painting none of them. It is the intentions of the artist that should be clear. The composition should unite and express these ideas. You should learn to be objective about your own work and this will help you to assess the work of other painters.

Ways of analysing the composition of your paintings have been dealt with in:
- Getting Started, *page 37*
- Working Outdoors, *page 67*
- Still-Life and Interiors, *page 87*
- Figure Compositions, *page 97*

At this stage it would be a good idea to reconsider work done some time ago so that you can be more objective in your judgement. Re-working an old painting can be a thankless task and often you destroy the original intention. However, you could work from an old painting, using it as the subject matter for further paintings constructed in different ways, using a different medium and different colours. Try to be clear in your own mind about what it is you are trying to express in each painting. If you are still not sure what makes a good composition, examine paintings by well-known artists in which similar subject matter has been chosen to that you wish to paint. Make tracings of several and compare them with tracings of your own work. You will notice that a good painting

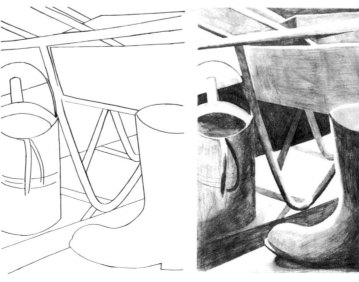

tells you where to look, how to look, how your eye should travel across, around, or focus on the painting.

It could be that you are too faithful to the subject and include things that upset the balance of the painting — *anything that is irrelevant to the total concept should be eliminated.* This applies to colour as well. For example, I remember doing a painting at the harbour one dull, grey day when the tide was out. My palette consisted of blue-greys, ochre, raw umber and white. Paul, aged eleven, said, 'Why haven't you painted in the life-belt box?'. I replied that I wasn't sure how to do it. If I used the red that it obviously was, it would upset the range of colours I was using and would make the box which wasn't that important dominate the painting. 'But it is to someone who's drowning, isn't it?' said Paul!

How carefully do you consider where you hang a painting on a wall, where you put furniture, how you arrange objects on the window-sill or mantelpiece, what you wear, and how you plan your garden? All these decisions are made in a similar way to organising a painting — you think about the balance and relationship of shapes and colours, modified by areas of texture and pattern. The more these kinds of decisions affect your life, the more likely it is to reflect in your painting.

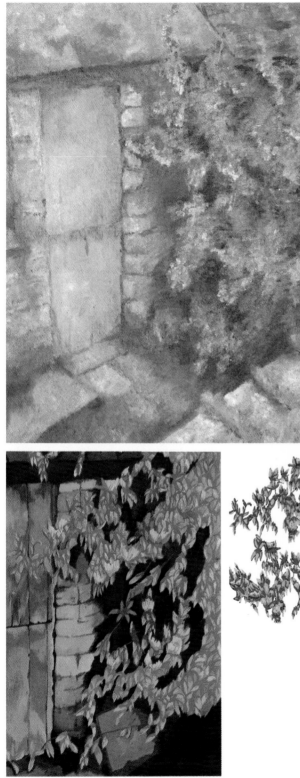

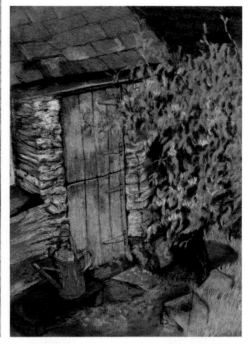

Plate 13 The same subject, by the same artist, in *top left* pastels, *top right* oils, *below left* gouache, and *below right* a design.

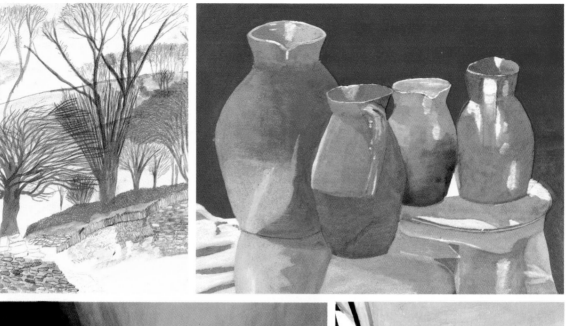

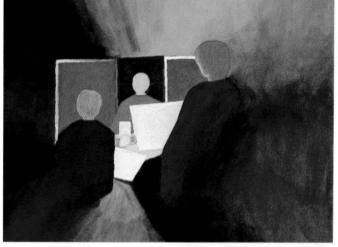

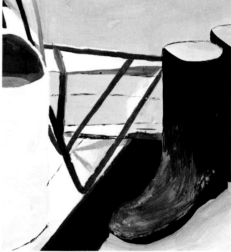

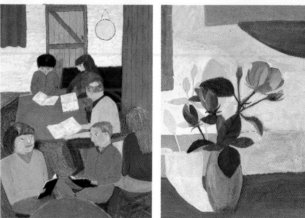

Plate 14 Development—a selection of one artist's work over a three-year period.

Chapter 7
Development

There is a stage in your painting development when it is difficult to see any real progress. You may have reached a plateau. The reason for this may not be complacency, but it is perhaps that the challenge is no longer there. Working on your own makes it even more difficult. A teacher in a class knows when to provide the new incentive to stretch your capacity further but deciding for yourself what this should be is not easy.

Being a member of a society or going to a class can help. Discussing the problems with a like-minded painter may be the stimulus you need.

Progress is difficult to see if each painting session is unrelated to the last and the next few sessions have not been considered. Planning a series or theme of work gives a structure to keep to or deviate from. It is exciting to see an idea develop in a series of paintings as this provides a strong motivation to tackle certain disciplines which previously have been avoided.

Sources of Ideas

What is it that inspires you and makes you want to express ideas in paint, and where do these ideas come from?

You could consider the sources of ideas related to:
- Subject matter
- Materials and techniques
- The language of painting

SUBJECT MATTER This can be landscape, still-life, interiors, flowers, and figure compositions. No doubt you have explored possibilities in each area. There are lists of ideas in the relevant chapters. Related ideas that are expressed differently can provide an incentive to approach the same subjects in another way. The study of light, for instance, can give you a wider range of subjects to choose from. To study this in any depth you would need to restrict the subject matter to a particular landscape, figure or interior. Have you seen the series of paintings that Monet did, showing the effect of light at different times of the day on Rouen Cathedral, the Thames, and the haystacks?

Consider the following:
LIGHT The effect of light on a landscape at different times of the day. Different weathers, different times of the year. Light related to still-life or figures cannot give you as many possibilities, unless you can provide the scope of stage lighting effects.

MOVEMENT The ways in which people move — on their own, in a crowd, as a group in particular activities, as well as the impression of speed. Also, movement of clouds, of trees in the wind, and the movement of water. Growth is related to movement but implies an understanding of how parts develop into a whole — as a tree develops branches from the trunk, and twigs and leaves from the branches.

SPACE A feeling of distance in landscape and the enormity of space. Divide space by looking through or beyond. Think of enclosed space and isolation. Try to understand space as a more abstract conception. Consider the way shapes or objects occupy the space and the sensations that are created.

FORM This would seem to be a total concept of shape, modified by colour, texture and pattern. In your painting it could involve you in attempting to explain structure and volume of a landscape, still-life or figure.

Think of the parallels with music, poetry, and literature. Consider relating your work to that of a particular painter, or group of painters.

These kinds of choices are very personal and the need to explore them has to be felt strongly to be of value. Such a study needs to be planned and suggestions are given later.

MATERIALS AND TECHNIQUES A particular interest in a certain painting technique, which may be new to you, can stimulate a change of direction in your work. Just having to learn a new technique will make you reassess your methods of working. There is a danger in being too competent. Another type of paint, used in a different way, and perhaps on a different scale, will give you a fresh stimulus with familiar subject matter.

THE LANGUAGE OF PAINTING Texture, pattern, line, tone, colour, shape and composition can be studied as specific exercises to explore the possibilities within one or more of these areas. Ideas for future work can develop from these studies.

Choosing a Theme and Planning a Series

Look through the book at all suggestions for subjects, ways of working, and materials. Make a list of the areas in which you are interested, and another list of those you ought to consider. Eliminate those which are not practical, e.g. sunlight on water would be an impossible theme for indoor work in the middle of winter! The theme you choose should be selected partly to improve some aspect of your work. You may choose to work in one area only, or one main area with a subsidiary aspect, such as colour or tone.

When you have decided your theme, way of working and subsidiary study, you could consider areas of reading to support this.

Make a list of possible subjects related to your theme and the exercises or experiments you will do. You should be realistic when planning how you will work as you need a balance of creative and experimental activity. Too many sessions doing exercises will bore you, but being totally involved in making

pictures will defeat the purpose of planned work. Your programme should provide a logical structure for your development but be flexible enough to be altered if necessary. The suggestions which follow could be used as a framework to make your own.

Suggestions

- THEME Landscape — development of sketches indoors
- WAY OF WORKING Oil paint on paper
- SUBSIDIARY STUDY Colour
- READING Eighteenth- and nineteenth-century landscape painters

THEME Different aspects of landscape:
Broad views or
Large open spaces or
Trees dividing the landscape or
Buildings related to landscape or
One view in different weathers, or different lights or
One view seen at a wide angle, and then others showing small areas or
Different aspects of one area or village, e.g. the church, the street, the valley.

WAY OF WORKING Two aspects need to be considered, firstly, making the sketches from which you will work and, secondly, the studio paintings.

The colour sketches could be done with oil on paper, which need not be sized for this purpose, but you may need to supplement these colour studies with pencil drawings as your sketches must provide enough information.

The surface you work on for your studio paintings must be properly prepared. Enlarging the sketches will present interesting problems. Will you do several paintings of the same size? Will you do several paintings of a medium size and one larger work?

SUBSIDIARY STUDY How much do you know about colour? Select from the section on colour (*page 127*) those suggestions that relate specifically to your needs and that of your main idea of landscape. You may, for instance, need to increase your knowledge of greens and greys for winter landscapes. You may want to work with a very restricted palette. The study of colour will provide another challenge when doing your studio painting.

READING You need to know the general background of the development of landscape painting but then restrict your area of study to:
— A few painters of a particular time
— A few painters working in a similar way
— A painter you particularly admire.

- THEME Interiors
- WAY OF WORKING Gouache
- SUBSIDIARY STUDY Tone
- READING Painters of interiors and still-life

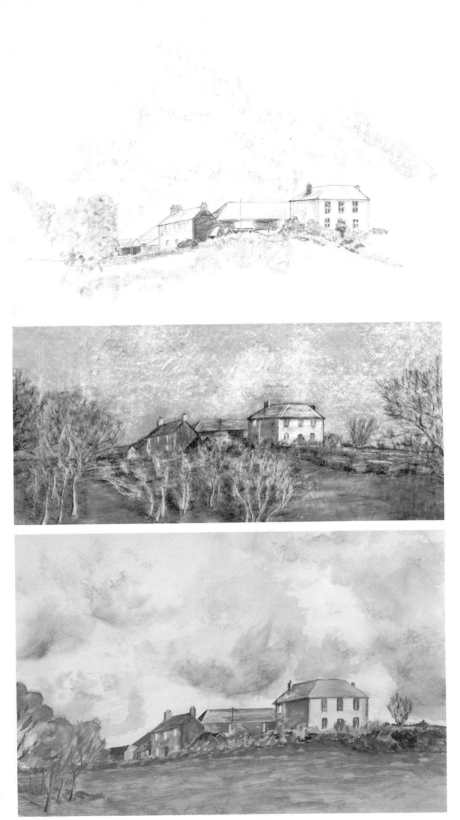

Top Pencil. *Centre* Pastel.
Below Gouache. All by the
same artist.

THEME For the interiors theme you need, of course, to be specific. You will find that in starting one study other subject ideas may follow. Suitable subjects may be: different areas of your own house; a view from the windows to include the interior area as well; certain types of domestic architecture, such as a farmhouse kitchen, or a Victorian or cottage kitchen; interiors with people in them, such as working in the kitchen, sitting by the fire, the family at breakfast.

WAY OF WORKING Will you use sketches to sort out your ideas and work from them? Will you work on the spot? If you are working in gouache then it is likely that your work will be on paper and on a small scale. Maybe you could try one much larger painting.

SUBSIDIARY STUDY Look at the section on tone (*page 122*) and select the experiments and ideas which are relevant. Your sketches for interiors could be considered as tone drawings and be developed to be complete in themselves.

READING General reading will help you to select a particular area to study. This could be the background interiors of Renaissance paintings, the Dutch painters such as Vermeer, the Impressionists, the early American painters, or interiors in engravings and book illustrations.

- THEME Figure compositions
- WAY OF WORKING Acrylic
- SUBSIDIARY STUDY Drawing
- READING Development of figure drawing through the ages.

THEME Unless you have the opportunity to go to life drawing classes or can find someone who will sit for you, portraits and detailed paintings are not a practical proposition. However, figures in a landscape, or an interior in a working situation can provide a fresh element in your painting, but as part of the composition and not the sole reason for it. Try to restrict yourself to a theme and look at the suggestions in the chapter on figure composition (*page 142*).

WAY OF WORKING You will need to consider how you will make your sketches and how you are to prepare for the studio painting. The sketches will have to provide a lot of information. Some will be quick pencil sketches others more careful studies, a few of which need to be in colour. Acrylic paints can be used like watercolours for these. Consider the size and surface of your studio paintings.

SUBSIDIARY STUDY Attending a life drawing class would be ideal. Your main theme will demand good drawing, so make the opportunity to do as much as possible. Suggestions for ways of drawing are on *page 119*.

READING Human figures have been the main subject of painting ever since painting began. It would be interesting to study how the artist's conception of the figure has developed through the ages and in different societies.

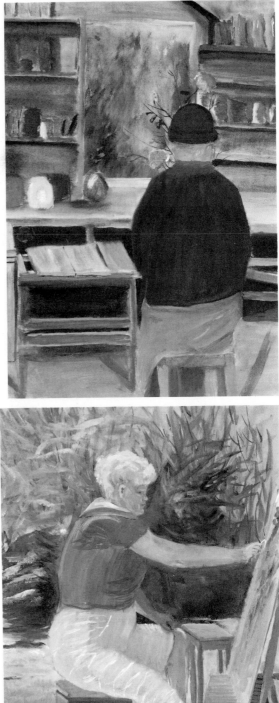

Three oil on paper studies
by the same artist.

- THEME Colour
- WAY OF WORKING Mixed, but oil where possible.
- SUBSIDIARY STUDY Effects of light on a landscape.
- READING Works on colour theory, and artists particularly concerned with theories of colour.

THEME You need to be a conscientious student to make a comprehensive study of colour. However, if you organise your time to balance the disciplined experiments with more creative studies you could find the experience valuable. Work through the exercises on colour (*page 127*).

WAY OF WORKING The experiments will be on paper which need not be sized for oils if the quality is reasonable. They will provide a useful reference in the future so the presentation needs to be good.

SUBSIDIARY STUDY The landscape you choose should be easily accessible and, if possible, one seen from your own home. Changes of light, weather and seasons can be recorded in a series of paintings. An established composition will allow you to concentrate on colour. As you progress with your experiments you may find new ways of using colour in your paintings.

READING You will want to increase your understanding of colour by wider reading. Generally, you could do this by studying the colour sections in other books on painting. Bernard Dunstan's *Painting Methods of the Impressionists* is a deeper study and easy to read. Most books on colour theory need serious study and may be available in a good library.

- THEME Relating your work to that of a particular painter, or group of painters
- WAY OF WORKING Poster paint
- SUBSIDIARY STUDY Composition
- READING Directly related to the main theme

THEME Which painter or group of painters will you choose and why? The Post-Impressionists to understand the development towards abstraction? The Pre-Raphaelites to get more realism and detail in your work? Turner and Constable as the two greatest British landscape painters? Rembrandt as the greatest portrait painter? The Impressionists because you like their work? Try to relate their work to yours and do not just copy their style and subject matter. You could find very similar subject matter and paint it in your own way. You could use the colours and techniques in a very different painting. You could develop their ideas in your own work. You could copy all or part of one of their paintings in a different medium.

WAY OF WORKING Much of the work for this theme can be considered as studies and, therefore, a medium such as poster paint on paper will provide fairly quick and satisfactory results.

SUBSIDIARY STUDY A professional painter's understanding of composition is probably what you will learn most from this theme. Work from the section on composition, relating it where possible to the main theme.

READING Read as much as you can about the painter, or group of painters, you have decided to study.

- THEME Related to music
- WAY OF WORKING Gouache
- SUBSIDIARY STUDY Pen and ink drawing
- READING Music and painting of the time chosen

THEME Composers are inspired to write music in the same way that painters decide to paint pictures. Try to think of expressing equivalent experiences rather than making direct illustrations. Images can occur when listening to music, even if the music is not intended to be programmatic. The idea is very personal so that it is difficult to make suggestions but, as an example, I once did a series of winter landscapes in water-colour as a parallel to Schubert's Song Cycle *Wintereise*. Your own ideas may be developed into a series of landscape paintings.

WAY OF WORKING You will need to do studies of the subject matter, which should be based on direct drawing and painting. When you have decided on those which are suitable for development, make further studies from them. A series needs some constant factor such as size, colour or composition. Gouache paint can be used in several ways, from an oil painting technique to water-colour. So, how will you work?

SUBSIDIARY STUDY Pen and ink could be used for the preparatory drawings and you could try combining this with water-colour washes.

READING As the choice of music has set the period, you could find out what was happening in painting at the same time.

- THEME Developing non-representational painting
- WAY OF WORKING Mixed mediums
- SUBSIDIARY STUDY Texture and pattern
- READING Twentieth-century painting

THEME You need something concrete to start from as vague ideas are likely to become larger and more definite statements of the same basic inaccuracies. So, start with a painting or drawing you have done: draw familiar objects from unusual angles, or deliberately enlarge or reduce their size, or develop one of the exercises on texture, pattern, shape, etc. Have a clear idea of what you want to achieve in composition, colour, shape texture, pattern, etc. Choose one area of subject matter, e.g. landscape, and develop several landscape studies in a similar way, or take one good painting and develop it in several ways.

153

A sequence of studies by the same artist based on the top pencil drawing. *Below* Watercolour. *Opposite* Oil on paper.

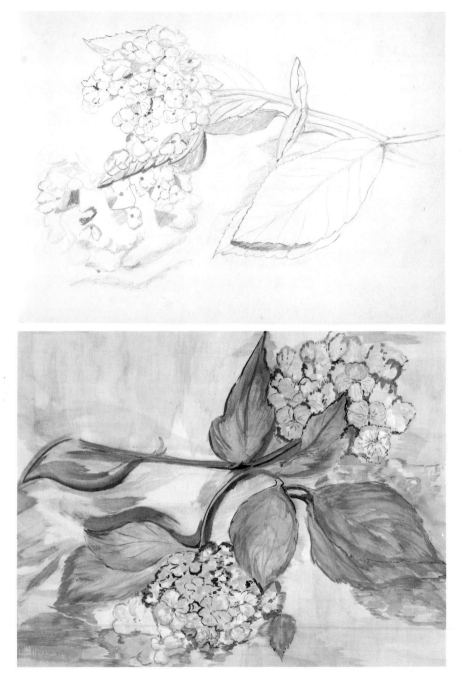

WAY OF WORKING Natural representation of the subject matter will not be important, but this is not an exercise to disguise the subject deliberately. Other factors will become more important such as the balance of form and colour, modified, maybe, by texture and pattern. The medium you work in will affect the results, so experiment with several mediums and vary the size of your studies.

SUBSIDIARY STUDY The surface of an abstract painting is quite important and large areas of one colour can be exciting if the surface texture or pattern has been carefully considered. Re-read the suggestions in chapter 6 and experiment with ways of changing the surface.

READING Read about the general development towards non-representational painting and then study one or two painters in particular. It would help you a great deal to visit exhibitions of modern paintings.

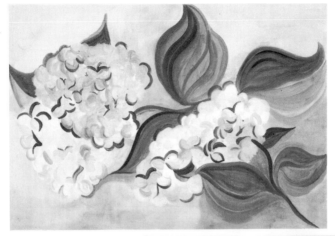

● THEME Related studies in different mediums

If your progress in painting seems to have come to a standstill, then the excitement of working another way may be just what you need. This could be restricted to the two-dimensional field, using various mediums for drawing and painting, or it could extend to lino and screen printing, modelling in clay, and sculpture. The choice of subject does not matter as long as it has the possibilities for development. It would be better to start with a detailed drawing and a coloured sketch, then the whole or part of the drawing could be developed in various ways. The results will be modified by the medium chosen.

Three related pieces of
work in different mediums
by the same artist.
Left Woodcut. *Right* Chalk
and charcoal.

SUGGESTIONS References will be made to techniques which cannot be described in this book. The reader may have knowledge of some, or be stimulated to find out. Obviously, the possibilities for development are restricted by what is available, or what it is reasonable to provide.

Working from a drawing, or from a seated figure, you could make a model in clay. You may need further sketches from the side or back of the figure to help you to do this. Next, you could draw from your clay model in different lights and from different angles. Then you could develop one drawing into flat areas in a collage by using newspaper, or coloured papers. Select a small area of the collage to use as a basis for a screen print or lino-cut. Experiments with different ways of printing will produce another series of shapes which could be used for a relief sculpture in pieces of wood.

Working from a still-life drawing, you could make a textured picture using different materials, like sand, sawdust, small stones, lentils and rice, which are

Sculpture in Chilmark
stone.

stuck with a strong glue to a board. A drawing of the modified shapes produced
in the textured picture could be used as templates to make cut-outs in card
which could be re-organised into a three-dimensional structure. Drawings
from this structure in different lights could then be used as the basis for a paint-
ing.

Working from a drawing of a plant, you could make a plant-like structure,
using wires of different thicknesses from fencing wire to fuse wire. Next, you
could light this structure so that it threw shadows on white paper, and then
draw the shadows. From this drawing you could make a lino-cut or woodcut.

The possibilities of working in this way are endless, once you accept that learn-
ing to paint is not just producing pictures in oil or water-colour, but only one
means by which you express what you know and what you feel about the things
you see.

157

Chapter 8
Presentation

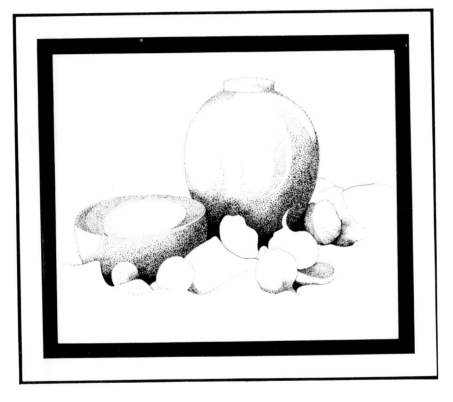

The presentation of your work is important. Whether you want to submit paintings for an exhibition or show them to your friends in your own home, you should present your work in a way which shows it to the best possible advantage. There is nothing more irritating than being shown a selection of work on scrappy, badly cut pieces of paper, or paintings in unsuitable or obtrusive frames. It is not the intention here to teach you to make your own frames, which is a job better left to the expert, but to help you know what to ask for when taking a painting to be framed and to make your unframed work presentable. There are several areas which need to be considered:

- Storing of completed work
- Mounting paintings and drawings on paper or card
- Making a folder
- Compiling a folder
- Display on a wall, pin-board or screen
- Framing
- Preparing for an exhibition
- Getting work printed
- Writing and lay-out

Storing Work

Finished work on boards and canvases, etc., should be stored upright, so that one does not damage the surface of another. Finished work on paper should be trimmed using a knife, steel ruler and set square, if necessary. If it is to be framed later, allow at least 12mm ($\frac{1}{2}$ in) all round for inset mounting. Paper should be stored flat and drawings likely to smudge, covered. Whether you do any more than this depends upon what you intend to do with your work. If it is going to be framed eventually then leave it. If you just want to keep a personal record of your progress then leave it. If, on the other hand, you wish to display your work at home or in a folder, it needs to be mounted.

Mounting

Inset mounts with bevelled edges in thick card need the professional's hand. However, superficial mounting and straight-cut inset mounting with thin card or paper can be done effectively by the amateur who is careful and has a basic range of equipment and materials.

160

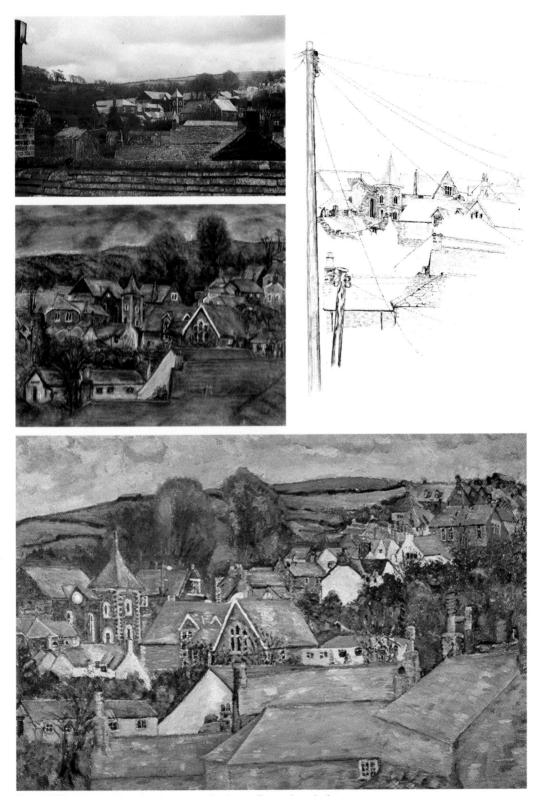

Plate 15 The same subject, by the same artist, in pencil, pastels and oil on canvas.

Plate 16 End of term exhibition.

You will need:
- A sharp cutting knife — those with snap-off blades are ideal.
- A metal ruler — carpet-edging provides a good straight edge.
- Wood or plastic rulers, although necessary for measuring, are easily damaged.
- A cutting board — thick card or hardboard.
- A set square to check right angles.
- A pencil to mark measurements. On dark card or paper, a pin mark will do instead.

● MOUNTING PAPER OR CARD Coloured card can be provided by a printer or good stationer; thicker mounting card and heavy coloured papers can be supplied by an art shop or framer. Keep at least two or three colours in stock.

● GLUE The sort used depends on what is to be stuck and how permanent it has to be. Spray glues are ideal for thin paper and allow repositioning; they do not stain or wrinkle the paper but, as with all aerosol sprays, should be used with care. Thicker paper can be stuck with cow-gum, PVA adhesives, etc. These glues can either be used thinly all over, taking great care, or in occasional spots, if it is necessary for the picture to be removed from its mount. Alternatively, with an inset mount, sticky tape can be used to fix the picture to the under-side of the mount. Many glues will eventually stain the paper, so make sure you use the right glue for the purpose.

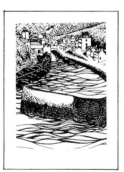
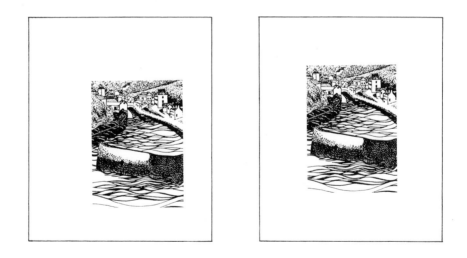

Once you have trimmed the painting or drawing (remember to allow 12mm [½ in] all round for inset mounting), you need to decide the colour and size of the mount. To make this decision you should try putting the picture on each of the coloured cards you have. When you have decided which colour to use, you can determine the size of the mount. There are rules about the right proportions, but if you have a 'good eye' you can break most of them. In any case, the proportions may be changed depending on the purpose, so that a

picture in a folder may have a large mount, but to go on a wall or pin-board it will only need a small border. Generally, a small border will look better if each side is the same size, or possibly with the bottom edge one and a half times the width of the sides and top edge. Having decided, cut your mounting card, using the knife and steel ruler, but do check the right angles first. Superficial mounting only requires the glueing of the picture to the mount.

Inset mounting is not difficult with thin card, provided you have measured the window-frame accurately and can cut precisely. It takes a lot of practice to do well. Place the frame over the picture, make sure it looks right, and then fix the picture to the underside of the frame using sticky tape or glue. You may need backing card to make the whole thing more rigid. Good mounting should be neat and unobtrusive; if it is done well it can make an enormous difference to the impact of a painting.

Making a Folder

Folders are expensive but they are necessary as a means of presenting work and carrying it about. They are also useful for storage. It is quite simple to make one provided you have the space to do it as well as the materials and equipment. The size of the folder will depend on what you put in it. The instructions are given for a folder to hold quarter imperial or A3 sheets and will measure 457mm × 317mm (18in × 12 ½ in).

You will need:
- Thick card or strawboard: one sheet Royal 635mm × 508mm (25in × 20in)
- Coloured paper for cover and inside cover: two sheets Imperial or A1
- Masking tape or carpet binding
- 10mm or ½ in cloth tape for ties — about 1500mm (5ft)
- Glue — thick Polycel or PVA medium
- Ruler — preferably metal
- Cutting knife
- Scissors

Figure 1 Mark out the measurements for the two cover pieces 457mm × 317mm (18in × 12½in) and for the spine 457mm × 19mm (18in × ¾in).

Figure 2 Using a knife and metal ruler, cut out the three pieces of card. Do the cutting on a surface such as card or hardboard where knife marks will not matter.

Figure 3 Measure out the covering papers 37mm (1½in) larger all round and cut mitred corners about 6mm (¼in) from the card. This will help to make tidier corners. Mark the position of the board on the paper. Cover the card with glue, making sure you have covered it properly, and then place the card on the cover paper. Turn it over and smooth out from the centre, making sure there are no air bubbles or wrinkles. Glue the overlaps, doing opposite ends, and then glue the sides. When you have done both pieces, put them under boards to dry flat.

Figure 4 Mark the places for the ties on the outside of the covers: in the centre of the three outside edges, and about 37mm (1½ in) from the edge. Carefully make six incisions the width of your tape. Cut the tape into six lengths of about 254mm (10in). Push them through the incisions and allow about 37mm (1½ in) inside. These are secured with a couple of pieces of masking tape.

Figure 5 Now, cut the inside cover pieces 25mm (1″) smaller than the cover on the three outside edges. Mark their positions, glue and stick down. Put both pieces under boards to dry flat.

Figure 6 Fixing the spine: you must allow the thickness of the card between the front cover and the spine, and the spine and the back cover. Put the masking tape down the centre of the spine and join to the front cover, and another piece from the centre of the spine to the back cover.

Turn the folder over and secure the overlap of masking tape. Do the same on this side and finish off with a third piece down the centre. Turn to the inside again and put the third piece down the centre. If you use carpet binding, one strip on either side would do, and you should start on the outside. Run the back of the scissors down the crease marks to make sure the folder bends easily.

The folder is intended to take loose sheets of paper which can be of varying sizes. However, you may require a folder to display a series of paintings and drawings, or photographs of your work. Fixing pages so that they are easy to turn over is difficult. You could adapt the design of the folder for loose sheets by making a thin vertical division on the front cover as you did with the spine, so that the pages can be secured with ties or rivets. Alternatively, you could sew several pages together and fix them to the folder covers like a book.

Compiling a Folder

There are many reasons why you may need your work presented in folder form. It could be for a project, for an examination, or to support an application to a college, or for an exhibition. A lot of work goes into compiling a folder so it is essential for the presentation to be good. Its function is to display work which has a theme, although the type and sizes of work may vary. You should try to give it as many constant factors as you can to achieve unity. First of all, you should be ruthless in editing the material to go in it. Then, you should group the work into logical units and decide if and where written explanations are necessary. Write these out separately, maintaining as much uniformity as possible. Next, you should decide on the background colour and type of paper or card for mounting your work. You may use a neutral colour throughout, or you may decide to change colours when the theme changes. Cut out the number of sheets necessary.

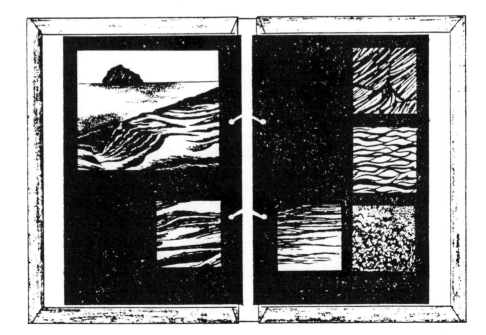

Now, you must consider the lay-out. The easiest way to do this is to spread everything on the floor, then you can select which pieces of work will go on each page and be able to consider each page in relation to the others. Try not to overcrowd the pages, and place the work in a logical order on each page. Balancing several works on one page does not necessarily mean symmetry. As a general rule, do not have too many vertical or horizontal divisions in your lay-out for it is confusing to the spectator. Methods of fixing the drawings, paintings or photographs to the mount have been dealt with on *page 160*.

Above all, remember that people looking through your folder are likely to flick through the pages fairly quickly so that the impression of the whole is important, but good lay-out will increase the impact of individual pages.

Display

The problems are similar to that of compiling a folder, only on a larger scale. To look at work in a folder you have to make a conscious effort to open it but a display of paintings, drawings, photographs, or postcards on a wall, pin-board, or back of a door or screen can have an impact on whoever passes for as long as it is there. The display can easily be changed and it does not involve expense or doubts about framing. You may choose an area of wall at home to display your recent paintings and drawings. You may want a small area for your working drawings and you may like to put up postcard reproductions of your favourite paintings. Decide what you want to put and where. The area for display may be flexible or restricted to a single screen. Consider the surface to be used and choose a suitable method of fixing your work to it. Walls are not the problem they used to be, when the use of sticky tape and glues pulled off the paint, as there are rubber-like adhesives which work very well, especially with small pieces of work such as postcards. Sticky tape across the corners of pictures looks dreadful, damaging both picture and wall. If you need something stronger to fix a large drawing to a wall, use double-sided sticky tape on the back. To create an area for the purpose you could use ceiling board, sundeala, hessian, cloth, corrugated card, cork tiles, etc. which will allow you to fix work with pins. Arranging the display needs the same consideration as for a folder.

Framing

Framing a painting seems to set the seal on its completion for it gives it an extra identity. In choosing the right frame for a painting you are influenced either by the painting itself, or by the environment where it is to be hung and, inevitably, you are inhibited by cost. A good frame-maker will show you various mounting cards and mouldings and will help you to choose the right frame for your painting. If you are not sure what is right, then choose the simplest frame possible, in plain wood rather than plastic substitutes, in a square section or simple bevel rather than an ornate moulding, and small rather than large. Thin metal frames look good, but do not suit all paintings and some environments.

Framing work for an exhibition is usually a compromise. If each painting is framed according to its needs, there is a lack of unity and a decision to use one

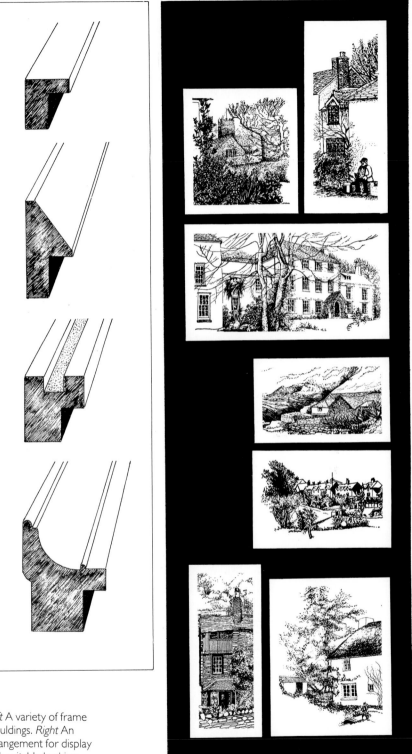

Left A variety of frame mouldings. *Right* An arrangement for display with suitable backing material.

type of framing means that some paintings have unsuitable frames. Bearing in mind that a buyer is likely to reframe the painting, it would be better to consider cost and find a simple frame that is neat and unobtrusive for the majority of your work.

Sometimes you can buy old frames very cheaply at jumble sales or auctions. Making one of these suitable for a painting can be fun and often quite effective. Of course, the size must be right for an oil painting but a frame with glass can be provided with a new mount, as long as the proportion is right. The frames can be cleaned and repainted, either in a neutral colour or in the dominant colours of the painting, so that the frame and picture become one. Some people enjoy making very decorative frames and even if you would not want it for a painting, you could try it for a mirror!

Exhibitions

There comes a time when you feel you should stand up and be counted. Fortunately, the process is gradual, but it is submitting your work for the first time that is difficult. Part of your decision is made when you have a painting framed and the next step is to submit it for an exhibition. Most art societies have members' exhibitions and if you join, you could take part in these. Progress towards a small group show and, eventually, a one-man show will depend on how successful you are as well as the amount of work you produce. Selling work is not necessarily the criterion for its value. Most amateurs ask for low prices and certain types of subject matter will sell easily. By implication, an exhibition is a time for assessment. Try to look at your own work objectively. Naturally, you will be pleased to see it exhibited, and even more delighted if you sell a painting, but consider your progress since last year and what your plans are for next year. Do not become complacent. Do not paint just to please other people. Let the start of each painting be the exciting prospect of learning something new.

Getting Work Printed

This need not be expensive, nor is it solely the prerogative of the professional artist. It is very satisfying to see your own drawing on a pile of printed cards, apart from which it can save or make you money. Today, small quantities of black and white drawings can be produced easily and cheaply by photocopying, and by letterpress or offset litho printing for quantities over five hundred. The method you use depends upon the size and quality of reproduction you require, as well as the quantity.

The simplest way is as follows:
Your drawing should be black on white. You could use a felt-tip pen, a technical drawing pen, mapping pen or brush and black ink. A range of tone is produced by varying the thickness of lines and the density of the marks made by dotting and cross hatching, etc. Tone produced by the shading of a pencil or ink reduced by water to a wash, requires a different and more expensive printing process. The drawing, to be reproduced at actual size by photocopying should not be larger than B4 (257mm × 354mm, or about 14in × 10in) for

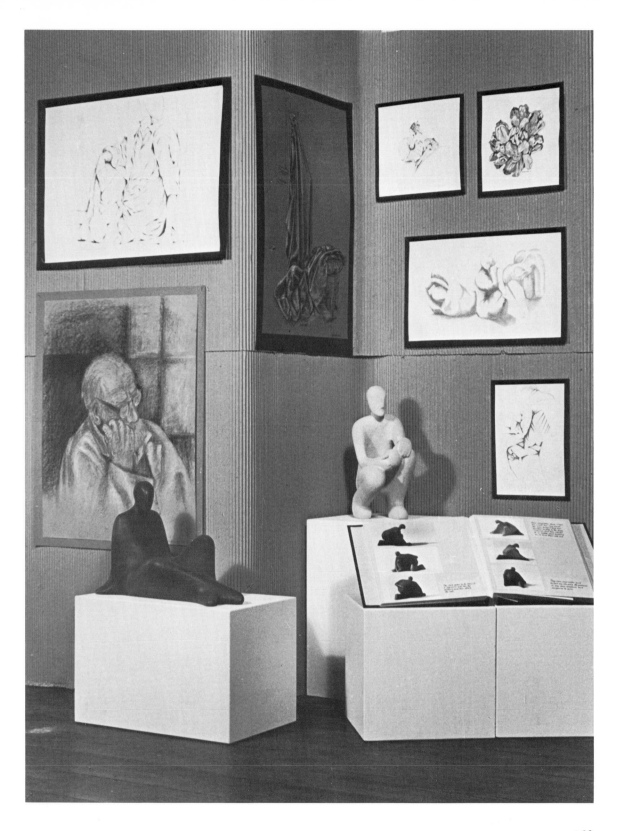

most photocopying machines, and many will not print larger than A4 (about 11 ½ in × 8 ¼ in). Small office machines often use sensitised paper which is not suitable for your purposes. In most places you will find a photocopying service where they print on good paper or thin card. The cost for printing a small number, say under ten, is reasonable and very good value at the hundred rate.

Once you have become familiar with the process you will realise that there are greater possibilities. For a minimal extra charge work can be reduced so that you can do a drawing at A5 size (about 5 ¾ in × 8 ¼ in) and have it reduced to A6 (about 5 ¾ in × 4in) which would be suitable for cards, notelets, letter headings, etc. It is wise to mount your work on thin card, the standard size used by the machine available, making sure your drawing is placed in the correct position.

Better quality and more versatile printing is available at your local printers: sizes are more flexible and there is a wide range of paper, card and colours. For quantities over five hundred it is usually cheaper than photocopying. The results are better if you allow for a 50% reduction of your drawing but you should consult the printer before you prepare your work.

Writing and Layout

Somehow, if you are known as an artist in any group, it is expected that your handwriting is good, so that you find yourself responsible for all the society's notices and posters. The advice here is for the person who is landed with such a job but is without the calligraphic skill to do it. Calligraphy is an art that needs a great deal of practice and, should you wish to learn, there are textbooks available. The immediate problem is how to make the best of your own handwriting and to develop it into a form which is clear, legible and pleasant to look at.

There are a number of things to consider which will not alter the character of your writing but will give you a version of it suitable for labels, notices and posters.

First, write out a couple of lines in your best handwriting and then analyse it as follows:

Is your writing upright or does it slope forwards or backwards?

Are all vertical strokes parallel or do they vary?

How consistent is your spacing between words?

Do the downward strokes below the line get muddled with the upward strokes of the line below?

Do you use unnecessary flourishes in certain letters?

Are all your letters legible?

Once you have realised what it is you do then you can do something about it. Re-write those two lines trying to do the following:

● Keep the writing consistently upright, or sloping forwards.
● Make sure the vertical strokes are parallel.

171

- Restrict the space between each word to one letter 'O'.
- Leave enough space between the lines of writing.

Be a good craftsman, it won't stop you being a genius.

This may be all that you need. However, there are other aspects you could consider:

If you find it difficult to keep the vertical strokes parallel, or your writing slopes backwards, it could be caused by the way you sit. Sit well and sit comfortably. If you are right-handed your paper should be straight, with the left-hand side of the paper opposite your middle. This will allow your arm to move freely across the page. If you are left-handed the paper should be placed at an angle with the right-hand bottom corner opposite your middle, or slightly to the left of centre.

The reason for having small spaces between each word, i.e. one letter 'O', is partly because it looks so much better, and partly to allow the reader to read fluently rather than hopping from one word to the next.

If the down strokes of one line get muddled with the up-strokes of the line below, or you find it difficult to keep straight lines, then you should rule guide lines or use a guide sheet.

This simple guide sheet can be made, using standard ruled paper with another line to give the height of capitals and ascender letters. Vertical divisions can be ruled for margins and insetting.

All writing is done on thin paper and then spray-mounted onto card or thicker paper. This serves most purposes for notices and labels under A4 (about 12in × 8in).

If some of your letters are illegible, then practise them. You may be holding the pen too tightly or awkwardly. Capital letters should also be practised. Do not try to imitate forms of letters unnatural to you — make your own as good as you can.

What should you use to write with?
For normal-sized notices, etc. use a fountain pen with a broad nib. An italic pen will give the writing more style but you will need to practise using it. For larger notices you could use a very broad italic pen, a poster pen, a brush or, much easier, a felt-pen which has a chisel edge — this is quick and effective and there is a good range of colours available.

LAY-OUT Using pencil, make a rough draft of what has to be said. Decide which sentences or information need a new line, which words need emphasis. You will have decided the over-all size of the notice, the sort of paper or card you will use, the colours and the pen you will use. All notices should be concise, clearly written, should read easily, and look attractive. It takes a long time to plan a notice where the words are evenly divided either side of a central line. Each line has to be written once at the finished size, then measured and divided to be placed centrally. If you are going to reproduce the notice by photocopying you could write each line separately and paste-up a master copy. It is easier to work to two or three vertical divisions, say the margin, 12mm (½ in) from the margin, and maybe 25mm (1in) from the margin. Each line, depending on its length, size of letters and importance, will start at one of these lines.

Another way to give emphasis to certain lines is to do all the writing on white paper, cut across each section and paste-up on a dark or bright-coloured card, leaving spaces between each section.

Obviously, it takes a lot of practice to do well and you may feel encouraged to learn a particular style of lettering. No artist should be content with bad writing and lay-out. Everything an artist does, whether in painting and drawing, presentation of work, choosing and arranging furniture, should reflect an acute awareness of the order and pattern of the visual world.

Index